Collins gem

Weather

Storm Dunlop

HarperCollins*Publishers* Ltd.
77-85 Fulham Palace Road
London
W6 8JB

www.collins.co.uk

First published in 1996
This edition published 2004

10 09 08 07 06
10 9 8 7 6 5 4

The copyright in the photographs belongs to Storm Dunlop
except for the following:
Trevor Buttress, Chichester 146, 159, 227; Stephen J. Edberg,
Pasadena CA 93, 107, 125, 136, 148, 149, 153, 155, 175, 217,
219, 221, 229; Eumetsat, Dermstadt 180-183; David Gavine,
Edinburgh 61, 100, 139, 141, 152, 158; Richard Griffith,
Horsham 150, 167, 237; Mike Magsig, Norman, OK, 225; Brian
Manning, Stakenbridge 123, 160; Ray Marsh, Chichester 97;
Nasa 164, 173, 195, 231, 233; University of Dundee 185, 187,
189, 191, 193; Duncan Waldron, Stow 21, 49, 101, 114

ISBN-10: 0-00-719022-0
ISBN-13: 978-0-00-719022-5

Printed in Italy by Amadeus

CONTENTS

How to use this book

The information given in this book is illustrated with colour photographs. You can look through the pictures until you find something similar to what you have seen. Even if it is not precisely the same, the details and page numbers given there will help to guide you to the correct description. If you know the name of the type of cloud or other phenomenon that interests you, it is easiest to use the index to find what you want. If you come across any words you do not understand, try the glossary. Space consideration prevents a full description of every photograph, but these have been very carefully chosen to show some of the vast range of different forms that may be obvserved. They are positioned to illustrate the conditions described in the text on the same or facing page.

Identifying clouds
It is a good idea to start by learning to recognise the basic cloud types (pp.22-53). Once you are familiar with these, you can begin to identify some of the many variations that occur (pp.54-85). Optical phenomena, together with cloud and sky colours, are described in a later section (pp.120-141).

How the weather works
It helps to have an idea of why clouds develop in the way they do and how certain other processes affect the weather. Cloud formation is illustrated on pp.94-101, and similar sections cover water in

all its forms (pp.142-161), wind (pp.162-170) and more general descriptions of the world's weather patterns and climate (pp.172-177).

Recording the weather
Satellites play an important part in modern weather forecasting, so satellite images and related weather charts are shown (pp.178-193). The final section (pp.234-247) provides some information about how to observe the weather and photograph the sky, together with details of how actual observations are made, with information on weather forecasting, extreme weather and weather records.

Defining terms
A glossary (pp.250-252) explains some specialised terms, most of which are also covered in the text.

Note:
For reasons that are explained on p.162, winds curve in different directions in the northern and southern hemispheres. Where this difference applies, the main description is for the northern hemisphere, but southern-hemisphere directions are always indicated in square brackets: e.g. 'northerly [S] wind'.

Introduction

The weather is always with us and, even in this modern age, affects nearly everything that we do. Yet we can all too easily feel that it is too complex to understand. This book aims to provide a simple introduction to the weather and to provide a guide to what is happening in the sky. The ever-changing clouds and sunshine, wind and rain, are then seen as part of even larger patterns that affect large areas of the world. The very diversity of the weather becomes a source of never-ending fascination for anyone who watches the sky.

All the photographs have been carefully selected, mostly to show 'typical' clouds and phenomena, rather than extreme, or rare, types that readers are unlikely to encounter. The exceptions, such as the photographs of tornadoes and hurricanes, help to illustrate the range of weather events and explain some of the processes that occur in the atmosphere.

Similarly, photographs have been chosen that show natural colours, approximately as they appeared to the eye at the time. Some phenomena, such as the purple light (p.109), present a challenge to any photographer, because of the limitations of photographic films. In these, and a few other cases, the colours observed were actually more vibrant or subtle than they appear here.

Familiarity with the different types of clouds and other phenomena, together with an idea of how and why they occur, adds considerable meaning to

the official weather forecasts, and also helps you to begin to make your own predictions of changes to come. The high, fast-moving streaks of jet-stream cirrus (above) for example, may be an indication of a coming deterioration in the weather (p.196), with the approach of a depression. A different type of forthcoming weather is indicated (opposite) where the current conditions are relatively quiet, but where the more distant clouds show some signs of possible showery activity later.

Learning to interpret the sky in this way is not particularly difficult and obviously has great practical value. But even the most hardened meteorologist finds that the sky always remains a source of great beauty.

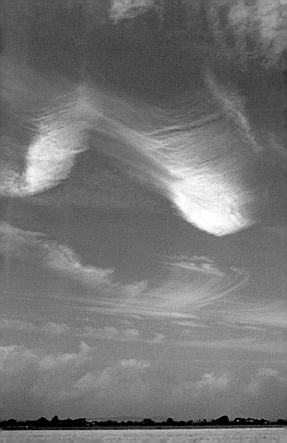

WATCHING THE SKY

Weather forecasting is now a complex science, relying on vast amounts of data from around the world and extremely powerful supercomputers. However, once you have some idea of what is happening inside the clouds, and in the various weather systems and situations, it will become much easier to interpret forecasts, and decide for yourself what the weather is likely to do.

Clouds provide clues to weather patterns and observing them can help you to gain an overall understanding of the weather.

The sky sometimes appears to be a chaotic mixture of clouds, and a quick glance cannot show what is happening. If you spend a little time, however, the different speeds at which the clouds move across the sky, and their changing appearance, enable you to sort out the different layers and types of cloud that are present.

The speed and direction of the clouds' movement may be deceptive. The wind speeds at different levels frequently differ very considerably. Again, watching the sky for a while will usually make it obvious what is happening. Wind direction is difficult to judge when clouds cover just part of the sky. When you are facing the wind, the effects of perspective make clouds to the right or left seem to be moving sideways across the sky. The remedy is simple: turn round and watch the movement downwind. This will give a much clearer idea of the actual wind direction.

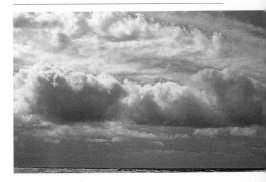

Don't forget, however, that the direction of the wind at the Earth's surface is normally slightly different from that at the level of the lowest clouds (see p.162). When facing downwind in the northern hemisphere, the surface wind is always farther to the left than the wind at low cloud level.

Perspective also causes clouds near the horizon to seem closer together than those overhead. It is sometimes difficult to tell whether a layer of clouds in the distance is, for example, an unbroken sheet of stratus or is actually stratocumulus. In such cases a pair of binoculars may reveal crepuscular rays (p.116) shining through breaks in the cloud or a regular pattern of shading, and thus decide the answer (overleaf).

11

Use binoculars to examine clouds in detail. Never use them – or any other optical aid – too close to the Sun, however, for you can damage your eyes.

The sky or clouds (especially near the Sun) are often too bright for details or certain optical phenomena such as iridescence (p.126) or haloes (p.128) to be seen easily. Sometimes it is sufficient to hide the Sun behind a hand or other object, but if not, there are other tricks you can try:

- Use sunglasses (the mirror type are particularly effective)
- View the sky reflected in glass or a pool of water
- Use a polariser to darken the sky

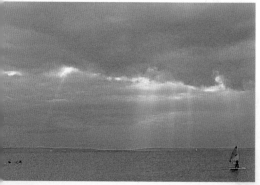

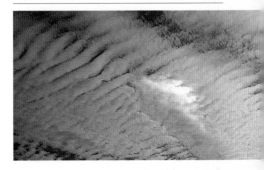

Reflections are a useful way of viewing the sky, particularly if no other means are to hand. Dark glass works extremely well, because it obscures the view of anything behind the glass, which may otherwise confuse details of the reflection. (The dark, tinted glass used in many modern buildings is often surprisingly effective.)

Any polarising material will accentuate the colours of rainbows and halo phenomena, making them easier to see. Polarising sunglasses or a camera filter are useful, although turning sunglasses at different angles in front of your eyes is not very convenient. Two pieces of cheap, plastic sheet polarising material are ideal, because, apart from their polarising effect, you can turn one relative to the other to vary the amount of light reaching your eye.

MEASURING ANGLES

It is often useful to estimate angles in the sky. For example, it is sometimes difficult to decide whether particular clouds should be called stratocumulus or altocumulus. If, 30° up from the horizon, the individual clumps of cloud are more than 5° across, then the clouds are stratocumulus. In the same way, haloes and other optical phenomena may be identified by their diameters.

Obviously, it is possible to use complicated gadgets to measure angles, but it is worth remembering that you can use any compass to measure horizontal angles, and some of the orienteering type enable you to measure vertical angles as well.

An easy way to estimate angles is to take an ordinary ruler, marked in centimetres. Hold it at arm's length at right angles to the body. Each cm is approximately equal to 1°. An even simpler method is to use your hand, held at arm's length. Perhaps surprisingly, this works for nearly everyone because people with larger hands tend to have longer arms. Here are some useful approximate measurements:

- 1° = width of 1 finger
- 7° = width over tops of 4 knuckles
- 10° = width of clenched fist
- 22° = width over spread fingers (thumb to little finger)

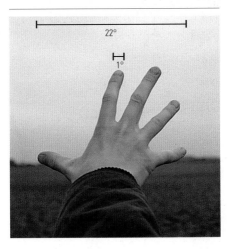

Some approximate, common angular sizes:
- 52° = radius of secondary rainbow
- 46° = radius of outer halo
- 42° = radius of normal (primary) rainbow
- 22° = radius of inner (most common) halo
- 5° or more = width of stratocumulus cloudlets
- 5°–1° = width of altocumulus cloudlets
- 1° or less = width of cirrocumulus cloudlets
- 0.5° = diameter of Sun or Moon

IDENTIFYING CLOUDS

The best way of recognising clouds is to begin with the ten cloud types, which are classified by their forms (i.e. their overall shapes) and their heights. These main types are reasonably easy to identify. Other, secondary features, described later, will enable you to recognise many other varieties of cloud.

Meteorologists use a classification that is similar to the Latin names employed for plants and animals. Clouds are arranged in genera (the ten types described first), species and varieties:

- genus type of cloud (pp.22-53)
- species cloud shape and structure (pp.54-71)
- variety arrangement of elements and transparency (pp.72-77)

Cloud forms

The three basic cloud forms are:

- cumulus heap clouds
- stratus layer clouds
- cirrus hair-like or feathery clouds

These are also the names of three specific types. The same words, or variants, occur in the compound names for the other seven major types. The standard, two-letter abbreviation is shown at the top of the section for each type.

There was once a fourth form: 'nimbus' (meaning 'rain-bearing'). Reminders of the name remain in the types called nimbostratus and cumulonimbus, though other clouds also produce rain or snow.

Cumulus clouds (heap clouds) are generally isolated, rounded heaps of cloud, sometimes better described as rolls or even 'pancakes'. The type known simply as 'cumulus' is widely recognised, because it is commonly called 'fair-weather clouds'. The cumuliform (cumulus-like) clouds are:

- cumulus Cu (p.22)
- stratocumulus Sc (p.28)
- altocumulus Ac (p.32)
- cirrocumulus Cc (p.46)
- cumulonimbus Cb (p.48)

Clouds often change into other types. Cumulus, for example, may rise to a certain height and then spread out sideways, combining with other individual heaps to give an extensive sheet of stratocumulus or altocumulus.

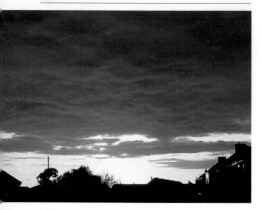

Stratus clouds (layer clouds) are widespread sheets, often dull and relatively featureless. They either occur as isolated patches or cover the whole sky. Depending on their height, some may arise above lower, cumulus clouds.

The stratus family consists of:

- stratus St (p.26)
- nimbostratus Ns (p.38)
- altostratus As (p.36)
- cirrostratus Cs (p.44)

Just as cumulus clouds may spread out into layers, so any of these stratiform (stratus-like) clouds may break up into related cumulus types.

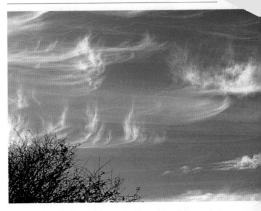

Cirrus clouds (hair-like or feathery clouds) consist of thin wisps or curls of cloud. Although this is the characteristic form, they also occur as much larger sheets or clumps of cloud.

The three types in the cirrus family are:

- cirrus Ci (p.40)
- cirrostratus Cs (p.44)
- cirrocumulus Cc (p.46)

Note that there is some overlap between the families. Cirrostratus and cirrocumulus may be regarded, respectively, as members of the stratiform and cumuliform groups, as well as of the cirrus family.

...re also classified by the height of their
...with broad categories of high, medium and
...The names reflect the fact that specific types
...cur at particular levels. The division is rough,
however, because the high and medium levels
partially overlap, and some cloud types
(particularly cumulus and cumulonimbus) may
extend into two or even all three levels.

The range of heights and the maximum
altitudes of medium- and high-level clouds (in
particular) are greater towards the equator than
near the poles. This reflects differences in the
height of the tropopause (the boundary between
the troposphere, where most clouds and weather
are found, and the overlying stratosphere – see
p.96). Similarly, cloud heights tend to be lower
in winter than in summer. The figures quoted
give an approximate idea of the height of cloud-
base at middle latitudes. (In aviation, the
worldwide standard is to give the heights of
aircraft and clouds in feet, so these equivalents
are shown.)

Cloud heights are notoriously difficult to
estimate without considerable experience or
equipment. Luckily, the characteristic cloud
types themselves are fairly easy to recognise.
Some simple ways of estimating the angular size
of certain clouds (which helps to determine their
types) are described on p.15.

Low clouds: bases below 2 km (approx. 6,500 ft)

- cumulus Cu (p.22)
- stratus St (p.26)
- stratocumulus Sc (p.28)

Medium-level clouds: bases at 2–6 km (approx. 6,500–20,000 ft)

- altocumulus Ac (p.32)
- altostratus As (p.36)
- nimbostratus Ns (p.38)

High clouds: bases above 6 km (approx. 20,000 ft)

- cirrus Ci (p.40)
- cirrostratus Cs (p.44)
- cirrocumulus Cc (p.46)

The one remaining cloud type, cumulonimbus, Cb (p.48), regularly stretches through all three levels (below). Other variations will be discussed later with the individual cloud types.

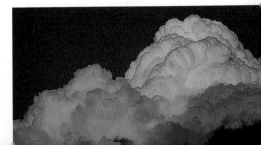

CUMULUS Cu

Cumulus clouds are easy to recognise. They are the fluffy clouds that float across the sky on a fine day, and are often known as 'fair-weather clouds'. The individual heaps of cloud are generally well separated from one another – at least in their early stages. They have rounded tops and flat, darker bases. It is normally possible to see that these bases are all at one level. Together with stratus (p.26) and stratocumulus (p.28), they form closer to the ground than other cloud types.

The colour of cumulus clouds, like that of most other clouds, depends on where they are relative to the Sun and the observer. When illuminated by full sunlight they are white – often blindingly white – but when seen against the Sun, unless they are very thin, they are various shades of grey. This should be borne in mind when reading the descriptions.

Appearance	Generally white, rounded tops and darker, flat bases.
Optical phenomena	None.
Height of base	Below 2,000 m (approx. 6,500 ft).
Precipitation	Normally none, but rain may fall from cumulus congestus (p.58).

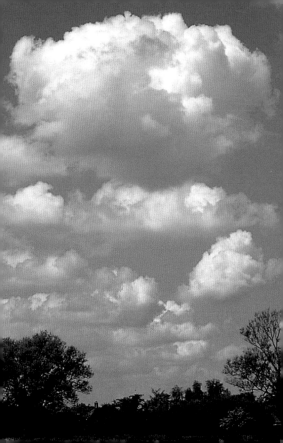

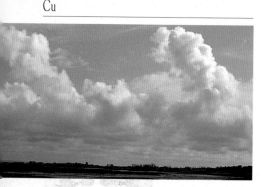

Cumulus clouds are the visible sign of bubbles of warm air (thermals) rising from the ground when it is heated by the Sun (see p.94). Individual thermals generally last for a few minutes and then decay. You can see this process at work if you watch what happens to an individual cloud. Isolated cumulus fade away as the moist air forming them gradually mixes with the drier air from their surroundings.

Early in the day cumulus are often like small wisps of cotton wool. As heating increases more thermals arise, which produce larger clouds. These also decay, and may become very ragged in shape rather than rounded heaps if there is a stiff wind blowing. All the thermals (and ordinary small cumulus) die away towards dusk.

Frequently, many active cells occur close together and combine to give a cloud that covers a larger area or is much deeper (or both). Deep cumulus often lean downwind, because the wind speed is usually greater at higher altitudes. Sometimes, however, high vertical towers may build up. When heating is particularly vigorous, cumulus may evolve into much heavier cumulus (cumulus congestus) that may even produce some rain, or turn into cumulonimbus clouds (p.48).

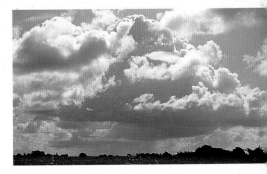

See also the following species of cumulus:
- cumulus humilis flattened cumulus (p.56)
- cumulus mediocris medium cumulus (p.57)
- cumulus congestus heaped cumulus (p.58)
- cumulus fractus ragged cumulus (p.60)

STRATUS St

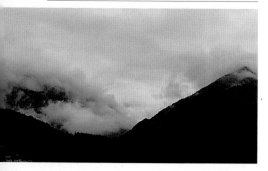

Stratus is a low, grey, water-droplet cloud that may hide the top of high buildings. It often has a fairly ragged base and top, and is identical to fog, which is stratus at ground level. Although the cloud may be so thin that the outline of the Sun is seen clearly, generally there are no optical phenomena. It forms under stable conditions (p.99) and is one cloud type associated with 'anticyclonic gloom' (p.211).

Appearance	Grey, nearly featureless blanket of cloud, sometimes ragged at top or bottom.
Optical phenomena	None; disc of Sun or Moon sometimes visible.
Height of base	Low, even on the ground.
Precipitation	Slight drizzle; a few snowflakes or ice crystals.

Stratus forms either by the slow uplift of moist air, or when a gentle wind carries nearly saturated air across a cold land or sea surface. It tends to arise when wind speeds are low, because strong winds mix a deep layer of air, which normally prevents the cloud from forming. However, stratus may occur, even with strong winds, when there is a large temperature difference between the air and the surface. Stratus also often forms when a moist air stream brings a thaw to ground that is covered in snow.

There is not much precipitation from stratus, because it is a shallow cloud, but it may produce slight to moderate drizzle or, when conditions are cold enough, a dusting of snow or ice grains.

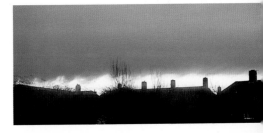

See also the following species of stratus:

STRATOCUMULUS Sc

Stratocumulus is a low, grey or whitish sheet of cloud. Unlike stratus it has a definite structure, with separate masses of cloud. These clumps, broader 'pancakes' or rolls show dark shading and are outlined by thinner (and paler) regions of cloud or by blue sky. The cloud masses are more than 5° across (measured 30° or more above the horizon). If smaller in size, the cloud is altocumulus (p.32).

Appearance	A distinct layer of regular heaps or rolls of cloud, with dark shading.
Optical phenomena	Generally none; sometimes corona (p.124) or iridescence (p.126) when thin.
Height of base	Below 2,000 m (approx. 6,500 ft).
Precipitation	Light, if any, and may not reach the ground.
See also	Inversion (p.96), virga (p.84)

Stratocumulus generally arises in one of two ways. In the first, cumulus clouds rise from the surface until they meet an inversion, where they flatten and spread out sideways, producing fairly even clouds with flat tops and bases. Early in the day there may be large areas of clear sky, but these gradually shrink with the increasing cloud.

The second method of formation is when convection breaks up a sheet of stratus. The regions of thinner cloud or clear air show where the air is descending, and the thicker, darker centres show where it is rising.

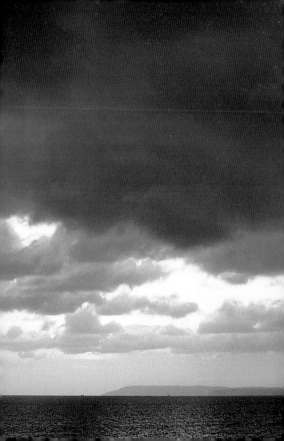

Sc

Some stratocumulus may be produced by shower clouds (p.212) and larger storm systems. Stratocumulus itself gives little precipitation, but sometimes there are fallstreaks (p.85) that do not reach the ground.

Satellite observations show that, over the whole Earth, stratocumulus is the most common form of cloud and occurs over large areas of the oceans. In general, it appears where gentle uplift of the air is taking place. The individual convection cells tend

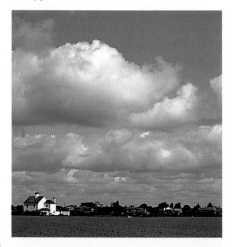

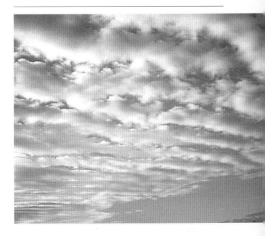

to be approximately the same size, leading to the regular pattern that is often observed. If there is wind shear at the stratocumulus level, striking, regular rows may develop.

Stratocumulus indicates stable conditions and only slow changes to current weather. Forecasters are often cautious about predicting whether a stratus layer will break up into stratocumulus and eventually disappear, as it is often extremely difficult to tell whether (and when) convection is likely to begin.

Altocumulus Ac

Altocumulus is a medium-level cloud, which occurs as individual, rounded masses with clear sky between them. It may appear in small, isolated patches, but is often part of an extensive layer. Like stratocumulus, but unlike cirrocumulus, the individual cloud elements always show some darker shading. They are also larger than cirrocumulus (more than 1° across, measured 30° or more above the horizon), and smaller than stratocumulus cloud masses, which are always more than 5° across.

Altocumulus clouds may contain either water droplets, which are usually supercooled, or ice crystals (or both). They may, therefore, exhibit a range of optical phenomena, depending on which form of water is predominant. Water-droplet effects (iridescence, coronae) are more frequent than those caused by ice (mock suns, sun pillars).

Appearance	Heaps, rolls or 'pancakes' of cloud, with darker shading and clear blue sky between them.
Optical phenomena	Iridescence (p.126) or corona (p.124) sometimes visible; more rarely mock suns (p.130) or sun pillars (p.134).
Apparent size	Individual cloudlets are 1–5° across – larger than cirrocumulus (p.46), smaller than stratocumulus (p.28).
Height of base	2–6 km (approx. 6,500–20,000 ft).
Precipitation	Rarely reaches the ground. Virga (p.84) frequently seen.

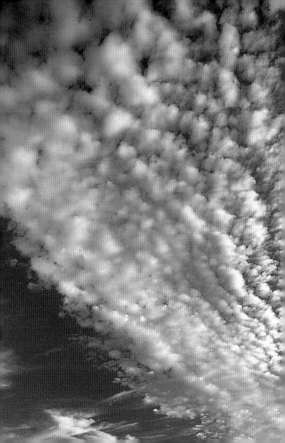

Ac

Like stratocumulus, altocumulus often forms when gentle convection begins within a layer cloud (altostratus) and breaks it into separate masses. Initially, these may be large 'pancakes', separated by narrow, cloud-free lanes of descending air (below). The clear regions grow as evaporation eats away the individual cloud elements until eventually the altocumulus may disappear.

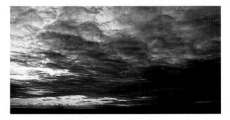

Layers of altocumulus move as a whole, carried by the general wind at their height. Wind shear often causes the cloud elements to become arranged in regular rolls, which usually lie across the direction in which the layer is moving. Billows (p.74) caused by vertical motion, may also occur. High altocumulus or cirrocumulus of this type gives rise to beautiful clouds, which are particularly striking when illuminated by the rising or setting Sun (opposite).

Again like stratocumulus, altocumulus may arise when ordinary cumulus clouds reach an inversion

and spread out sideways. Sometimes, after a temporary halt, the cumulus may resume growing and appear above the altocumulus layer. Similarly, altocumulus may remain after large cumulonimbus clouds (p.48) have died away. The fronts in depressions (p.196) are ideal places for the formation of altostratus and altocumulus. Both types of cloud often trail behind active fronts, and altocumulus is quite common among the mixed clouds in the warm sector (p.204) behind a warm front.

See also the following species and varieties:

- altocumulus lenticularis lenticular clouds (p.64)
- altocumulus floccus tufted altocumulus (p.66)
- altocumulus castellatus towering altocumulus (p.67)
- altocumulus stratiformis layered altocumulus (p.68)
- altocumulus perlucidus broken altocumulus (p.76)

ALTOSTRATUS As

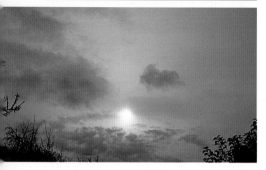

Altostratus is a dull, medium-level, white or bluish-grey cloud in a relatively featureless layer, which may cover all or part of the sky. When illuminated by the rising or setting Sun, gentle undulations on the base may be seen, but these should not be confused with the regular ripples that often occur in altocumulus (p.32).

As with stratus, altostratus may be created by gentle uplift. This frequently occurs at a warm front, where initial cirrostratus thickens and becomes altostratus, and the latter may become rain-bearing nimbostratus (p.38). Patches or larger areas of altostratus may remain behind fronts, shower clouds (p.212) or larger, organised storms. Conversely, altostratus may break up into altocumulus. Convection may then eat away at the

cloud, until eventually nothing is left.

When altostratus is thin, iridescence and coronae may occur around the Sun and Moon. These disappear with thicker cloud that contains ice crystals, and the Sun (or Moon) then appears to be shining through ground glass.

Occasionally, cumulus clouds may break through altostratus and its inversion and continue growing above the layer. This may sometimes be recognised from the ground by the darkening where the cumulus cast shadows on the altostratus.

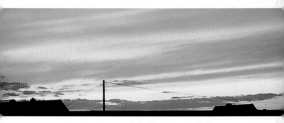

Appearance	Featureless, white or bluish-grey cloud layer.
Optical phenomena	Coronae (p.124) or iridescence (p.126) when thin.
Height of base	2–6 km (approx. 6,500–20,000 ft).
Precipitation	None at low level, slight drizzle (like stratus) if you are within it.
See also	Stratus (p.26), cirrostratus (p.44).

NIMBOSTRATUS Ns

Nimbostratus is a dark grey, heavy sheet of cloud, with a very ragged base. It is the main rain-bearing cloud in many frontal systems. Shafts of precipitation (rain, sleet, or snow) are visible beneath the cloud, which is often accompanied by tattered shreds of cloud (known as pannus, p.79) that hang just below the base. Rather larger, more organised, ragged clouds, called stratus fractus are also often found below nimbostratus.

Just as cirrostratus often thickens and grades imperceptibly into altostratus, so the latter may thicken into nimbostratus. This is, in fact, the usual succession of cloud at a warm front. Once rain actually begins, or shafts of precipitation are seen to reach the ground, it is safe to call the clouds nimbostratus.

The rain or other precipitation usually lasts for a long time. At a warm front it may continue for

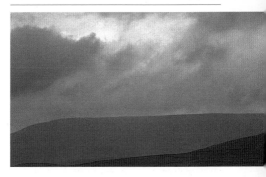

several hours, unlike the relatively short, intense rain from showers (p.212). The rain tends to be more or less continuous, but usually varies considerably in amount, ranging from light to extremely heavy. It will frequently cease for a time, then return, until eventually the front passes away from the observer.

Appearance	Very dark grey, ragged layer of cloud, often accompanied by separate shreds of clouds beneath it.
Optical phenomena	None; Sun and Moon invisible.
Height of base	Ground level to 2 km (approx. 6,500 ft).
Precipitation	More or less continuous rain, sleet or snow.
See also	Altostratus (p.36), stratus fractus (p.61).

39

CIRRUS Ci

Cirrus is a wispy, thread-like cloud that normally occurs high in the atmosphere. Usually white, it may seem grey when seen against the light if it is thick enough.

Cirrus consists of ice crystals that are falling from slightly denser heads (known as the generating heads) where the crystals are forming. In most cases wind speeds are higher at upper levels, so the heads move rapidly across the sky leaving long trails of crystals behind them. Occasionally, the crystals fall into a deep layer of air moving at a steady speed. This can produce very long, vertical trails of cloud.

The presence of the ice crystals is sometimes revealed by the appearance of a brightly coloured mock sun in the trailing cloud. Portions of other halo phenomena may occur from time to time, particularly parts of the circumzenithal arc, together with other, much rarer, optical phenomena.

Appearance	Wispy, thread-like cloud, often drawn out across the sky by high winds.
Optical phenomena	Mock suns (p.130), circumzenithal arc (p.132).
Height of base	Generally above 6 km (approx. 20,000 ft).
Precipitation	None reaching the ground, but cirrus actually consists of falling ice crystals.
See also	Virga (p.84), fallstreak holes (p.85).

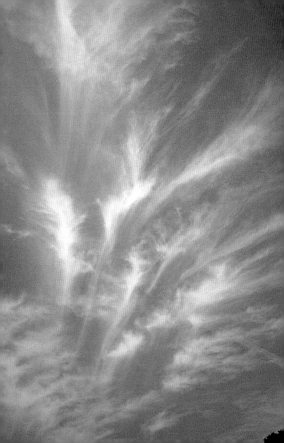

Ci

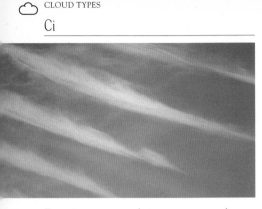

Extensive amounts of cirrus are commonly seen ahead of an approaching warm front. Under these conditions, moist air is being carried up into the higher layers of the atmosphere, where the water freezes into ice. Indeed, cirrus that slowly increases to cover the sky, when the individual trails of ice crystals gradually merge into a sheet of cirrostratus (p.44), is a recognised sign that a depression is on its way.

A cumulonimbus cloud often produces a large plume or anvil, which consists of a vast shield of cirrus that is carried far away from the storm itself by the high-speed upper-atmospheric winds. Sometimes very dense patches of cirrus remain behind long after the parent cumulonimbus clouds themselves have decayed and disappeared.

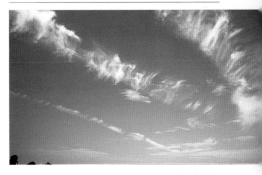

Cirrus is one of the main types of cloud that produces precipitation, together with nimbostratus and cumulonimbus. It is sometimes placed with them in a separate group of precipitating clouds. Unlike them, however, it consists of practically nothing but precipitation. Generally, the ice crystals fall into warmer layers of air, where they melt into water droplets and then evaporate without reaching the ground. Only at very high altitudes or in very cold regions (particularly in the winter) do snow or ice grains reach the ground surface.

See also the following species and one variety of cirrus:

- cirrus spissatus thickened cirrus (p.69)
- cirrus fibratus fibrous cirrus (p.70)
- cirrus uncinus hooked cirrus (p.71)
- cirrus intortus tangled cirrus (p.72)

CIRROSTRATUS 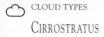 Cs

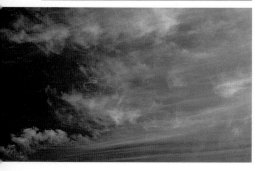

Cirrostratus is a sheet of high ice-crystal cloud, sometimes so thin that it goes completely unnoticed, because it has little effect on sunlight. For this reason, although common, it is probably the least recognised of the ten major cloud forms. Whenever the sky becomes slightly milky in appearance, it is possibly because a veil of cirrostratus has spread overhead.

Hiding the Sun may be sufficient to reveal indications of the cloud. In particular, it is usually possible to see a slight fibrous structure, reminiscent of cirrus. In fact, cirrostratus often forms when cirrus clouds gradually increase and spread to cover most of the sky in a more or less uniform layer of ice crystals. This often happens ahead of a warm front.

A definite indication of cirrostratus is the presence of a halo around the Sun or Moon. Optical phenomena such as mock suns or a circumzenithal arc may also occur. Haloes usually appear for just a short period, before the cloud thickens, and then disappear. By then, the cloud is normally dense enough to be readily visible. When a warm front is approaching, the cirrostratus thickens and descends, and eventually turns into altostratus.

Appearance	Milky veil of high-level cloud.
Optical phenomena	Haloes (p.128), mock suns (p.130), circumzenithal arc (p.132).
Height of base	Generally above 6 km (approx. 20,000 ft).
Precipitation	None.
See also	Altostratus (p.36).

CIRROCUMULUS Cc

Cirrocumulus is a very high, white or bluish-white cloud, consisting of numerous tiny tufts or ripples, occurring in patches or larger layers that may cover a large part of the sky. The individual cloud elements are less than 1° across. They are sometimes accompanied by fallstreaks (or virga).

Unlike altocumulus (p.32), the small cloud elements do not show any shading. They are outlined by darker regions where the cloud is either very thin or completely missing. These darker areas are where air is descending around the edges of the convection cells, causing the cloud to disperse.

The cloud layer is often broken up into a regular pattern of ripples and billows. Clouds of this sort are commonly called a 'mackerel sky' from their resemblance to the pattern of banding, although the term is sometimes applied to fine, rippled altocumulus. In fact, the differences between cirrocumulus and altocumulus are really caused

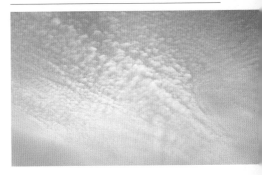

only because the latter are lower and thus closer to the observer.

Cirrocumulus consists of supercooled water droplets together with some ice crystals, so they may show optical effects such as iridescence or coronae or, less frequently, the various type of halo phenomena (p.128).

Appearance	Small heaps of pale, white or bluish cloud (less than 1° across), without shading.
Optical phenomena	Iridescence (p.126), corona (p.124).
Height of base	Generally above 6 km (approx. 20,000 ft).
Precipitation	None reaching the ground, but virga frequently seen.
See also	Virga (p.84), fallstreak holes (p.85).

CUMULONIMBUS Cb

Cumulonimbus is the largest and most energetic of the cumulus family. It appears as a vast mass of heavy, dense-looking cloud that normally reaches high into the sky. Its upper portion is usually brilliantly white in the sunshine (when seen from the appropriate angle), whereas its lower portions are very dark grey. Unlike the flat base of cumulus, the bottom of cumulonimbus is often ragged, and it may even reach down to just above the ground. Shafts of precipitation are frequently clearly visible.

Cumulonimbus clouds consist of enormous numbers of individual convection cells, all growing rapidly up into the sky. Although cumulonimbus develop from massive cumulus congestus, the critical difference is that at least part of their upper portion has changed from hard 'cauliflower' heads to a softer, more fibrous look. This is an indication that freezing has begun in the upper levels of the cloud.

Appearance	Massive, heavy, and very deep cloud, with dark base and precipitation. Part of the top has begun to lose the hard 'cauliflower' look.
Optical phenomena	Sometimes rainbows in rain beneath cloud.
Height of base	Below 2,000 m (approx. 6,500 ft).
Precipitation	Rain, snow in winter, hail.
See also	Cumulus congestus (p.58), incus (p.82), lightning (p.218).

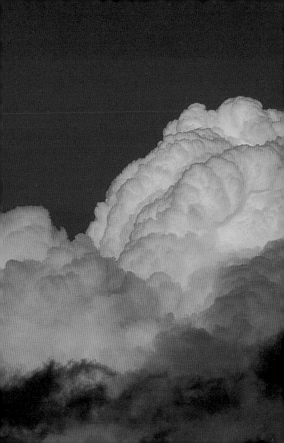

Cb

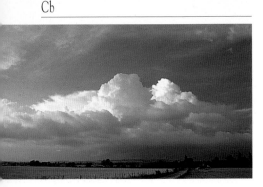

The appearance of the top of cumulonimbus clouds sometimes causes confusion. It may be rounded, like other cumulus clouds, but once freezing has become widespread it becomes flattened (opposite). This may take the form of a large plume of cirrus or an anvil (p.96). The latter often occurs when the rising cells reach an inversion, frequently at the tropopause. When the main cell is very vigorous, its top often penetrates the inversion and may be seen as a dome above the anvil.

With strong wind speeds at the freezing level, plumes and anvils may seem to 'explode', covering a vast area in just a few minutes. The cirrus shields above cumulonimbus are often so large that they are easily visible on satellite photographs (p.193).

If the cloud top is invisible, you can use other

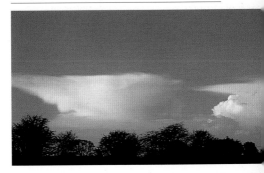

features for identification. Cumulonimbus is one of the two main rain clouds (the other is nimbostratus, p.38), although some precipitation may occur from other clouds and particularly from the somewhat similar cumulus congestus. When temperatures are cold enough, cumulonimbus may produce significant falls of snow.

The violent conditions inside cumulonimbus create gusts of wind and longer squalls at the surface, and may produce hail (p.148) or give rise to lightning (p.218) and its accompanying thunder. A cloud is therefore considered to be cumulonimbus if any of the following occur:

- a fall of hail
- thunder
- lightning

Cb

Individual cumulonimbus clouds are often described as showers (p.212): isolated, relatively short-lived downpours, unlike the extended periods of more-or-less continuous rain at the warm fronts of depressions (p.196). Cumulonimbus clouds are much more frequently associated with cold fronts and squall lines (pp.206 & 217).

The lifetime of a cumulonimbus that consists of a single active cell is relatively short. It takes around 20–30 minutes to build up as cumulus congestus, followed by an active stage that lasts about the same time. During this period there is heavy rain (and possibly hail or thunder) and the cloud becomes a cumulonimbus. The cloud then decays over 30 minutes to around two hours, with rain slowly decreasing.

Very often, however, a number of cumulonimbus cells interact to give a larger, or multicell storm (p.216). Here, although each individual cell has a similar lifetime, new cells repeatedly arise as older ones die away, so the whole storm continues for several hours. Even greater storms occur, particularly over continental areas. These are known as supercell storms (p.216) and may breed destructive tornadoes (p.224).

See also: Cumulus congestus (p.58), altocumulus castellanus (p.67), cumulonimbus calvus and capillatus (pp.62-63), cumulonimbus incus (p.82), cirrus spissatus (p.69).

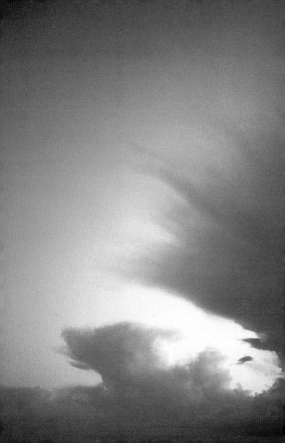

Cloud Species

The 14 cloud species are used to describe cloud shape and structure. Each term applies to one or more types of cloud. In this list, species are grouped approximately according to the types they describe, which are shown by their two-letter abbreviations. Some important species are illustrated on the following pages. There are also cloud varieties, which describe the arrangement of elements and cloud transparency (pp.72-77), and what are called accessory clouds (pp.78-85).

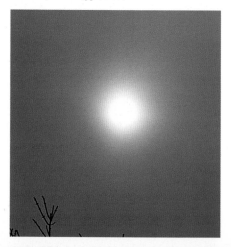

Species	Abbr.	Description	Cloud Type(s)
Humilis	hum	Flattened	Cu*
Mediocris	med	Moderate depth, tops with fairly small bulges	Cu*
Congestus	con	Markedly growing; often great vertical extent, with tops that resemble a cauliflower	Cu*
Fractus	fra	Ragged shreds of cloud	Cu*, St*
Nebulosus	neb	Thin veil or layer with no distinct features	St* (opposite), Cs
Stratiformis	str	Very extensive horizontal sheet or layer	Sc, Ac*, Cc occasionally
Calvus	cal	Tops look smooth (bald); losing cumuliform appearance, but no obvious cirrus	Cb*
Capillatus	cap	Distinct icy regions with fibrous, striated appearance (anvil, plume, or disordered mass of cirrus)	Cb*
Floccus	flo	Small tufts of cloud, with ragged lower portion, and often virga	Ac*, Cc, Ci
Castellatus	cas	Turrets connected by a common base, sometimes arranged in lines	Sc, Ac*, Cc, Ci
Lenticularis	len	Wave cloud: almond or lens-shaped	Sc, Ac*, Cc
Fibratus	fib	Nearly straight, or more or less curved, no hooks	Ci*, Cs
Spissatus	spi	Dense enough to appear grey towards Sun	Ci*
Uncinus	unc	Comma- or hook-shaped, not rounded tuft of cloud	Ci*

* This species is illustrated

CUMULUS HUMILIS Cu hum

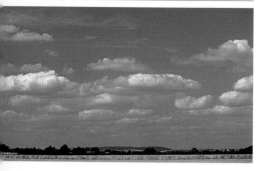

The cloud species cumulus humilis has a distinctly flattened appearance. It occurs when there is an inversion slightly higher than the condensation level. The spaces between the clouds are relatively large, unlike the situation when cumulus spread out and create a layer of stratocumulus (p.28).

Cumulus humilis are one sign of an approaching warm front (p.198). They also tend to occur under high-pressure conditions (p.210), when slowly descending air restricts the upward growth of cumulus.

Appearance	Flattened cumulus, much broader than they are deep.
Occurrence	In Cu only.
See also	Cumulus mediocris (p.57), cumulus congestus (p.58).

CUMULUS MEDIOCRIS Cu med

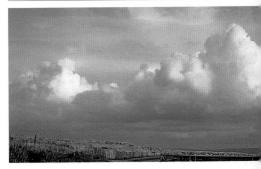

Cumulus clouds often show a moderate amount of vertical growth, with small bulges on their upper surfaces. They are called cumulus mediocris or medium cumulus. Although the clouds may lean slightly because of the increasing wind strength at higher levels, this is rarely very pronounced, simply because the clouds are not very deep.

Cumulus that are very actively growing, and show much greater vertical depth, are known as cumulus congestus.

Appearance	Cumulus of moderate depth, with restricted growing heads.
Occurrence	In Cu only.
See also	Cumulus humilis (p.56), cumulus congestus (p.58).

57

Cumulus Congestus Cu con

Cumulus congestus, or heaped cumulus, are large cumulus that are obviously growing extremely vigorously. Occasionally they may be fairly narrow vertical towers, but generally they have fairly broad bases. Unlike cumulus humilis, which have a depth of about 1 km at most, congestus may reach 2–3 km. Further development would turn them into cumulonimbus clouds.

The tops of these clouds often have a hard, 'cauliflower-like' appearance and their bases may be quite dark. Freezing does not occur in cumulus congestus, unlike in cumulonimbus, so the tops never acquire the fibrous look that indicates that ice crystals have been formed. In the temperate zones cumulus congestus may, on rare occasions, give rise to a shower. In the tropics, however, they are a frequent and plentiful source of rain.

Note that species of stratocumulus, altocumulus, cirrocumulus and cirrus clouds that exhibit active vertical growth are known as castellatus (p.67), rather than congestus.

Appearance	Actively growing cumulus, sometimes vertical towers; 'cauliflower' tops.
Precipitation	Rare in temperate regions; frequent and plentiful in tropics.
Occurrence	In Cu only.
See also	Cumulus mediocris (p.57), cumulonimbus (p.48), cumulonimbus calvus (p.62), cumulonimbus capillatus (p.63)

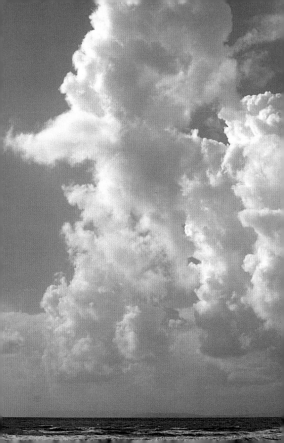

CUMULUS FRACTUS

Cu fra

Cumulus fractus are irregular, ragged tufts of cloud (unlike other forms of cumulus, which appear as rounded heaps) and occur under various conditions. They are often the first wisps of cumulus to appear during the day, and reappear as the cumulus clouds evaporate and disperse.

Cumulus fractus clouds are also found in the precipitation beneath cumulonimbus. They are normally paler than stratus fractus and have a deeper, more distinct, rounded form.

Appearance	Ragged wisps of cumulus cloud.
Occurrence	As Cu begins to form or breaks up; beneath Cb clouds.
See also	Pannus (p.79), precipitation (p.142).

STRATUS FRACTUS

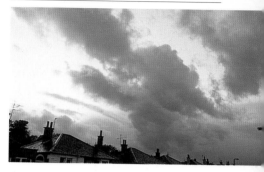

Ragged patches of stratus, called stratus fractus, often form beneath rain clouds such as nimbostratus or cumulonimbus, especially where the humid air beneath the rain cloud is forced to rise slightly, such as when passing over low hills. Stratus fractus is not as deep as cumulus fractus (opposite) and is generally much darker. When a layer of stratus starts to form (or decays) it generally appears as stratus fractus.

Appearance Dark, rapidly changing, ragged wisps of cloud.
Occurrence Beneath Ns or Cb; as St forms or breaks up.
See also Pannus (p.79), precipitation (p.142).

CUMULONIMBUS CALVUS Cb cal

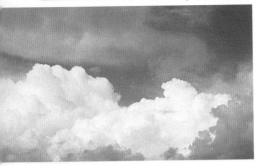

A cumulus cloud that has just turned into cumulonimbus is called cumulonimbus calvus, meaning 'bald'. The hard-edged top has become softer, with less detail visible. This is because freezing (known as 'glaciation' to meteorologists) has occurred in the uppermost portions of the cloud. Insufficient time has passed for the ice crystals to form specific features such as virga (p.84) within the cloud mass. This will happen in the next stage: cumulonimbus capillatus (opposite).

Appearance	Cloud towers have a softer look, with less distinct features.
Occurrence	In Cb only.
See also	Cumulus congestus (p.58), precipitation (p.142).

Cumulonimbus Capillatus Cb cap

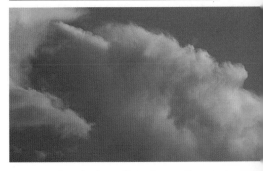

Cumulonimbus clouds usually evolve rapidly once freezing begins, turning from cumulonimbus calvus (opposite) into cumulonimbus capillatus. A fibrous structure is now clearly visible in at least part of the upper regions of the cloud. There may be distinct virga beneath an overhanging roll of cloud, or a ragged head of cirrus, which may rapidly extend downwind. If there is a true anvil the cloud is known as cumulonimbus incus (p.82).

Appearance	Distinct icy (fibrous) structure; anvil, plume or mass of cirrus.
Occurrence	In Cb only.
See also	Virga (p.84), precipitation (p.142).

ALTOCUMULUS LENTICULARIS — Ac len

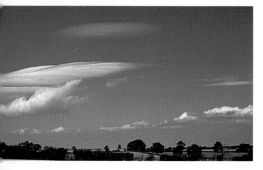

Altocumulus lenticularis are typical of the lenticular (or wave) clouds, which also occur in stratocumulus and cirrocumulus. Their outline is smooth in comparison with the lumpy appearance of most cumulus clouds. They occur where a layer of stable (p.98) air is forced upwards, usually by hills or mountains. Because the air is stable it descends on the other side and may sometimes set up a whole series of waves that stretch downwind and usually decrease in size with distance.

The clouds lie at the wave-crests, where the air is carried up above the condensation level. The first crest is usually quite close to the line of hills, but wave clouds may occur far from any high ground. The clouds may persist for hours if the wind and conditions remain steady.

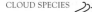

Air is flowing through the clouds, which are constantly forming on the upwind side, and evaporating downwind (you can often see this with binoculars). Sometimes there are several moist layers, and then the clouds may appear to be stacked one above the other. This is known as a 'pile d'assiettes' (French for 'a pile of plates'). Occasionally, the wave clouds themselves are broken into a pattern of smaller billows (p.74).

Appearance	Smooth, lens- or almond-shaped clouds that remain stationary in the sky.
Occurrence	In Sc, Ac or Cc, when the wind is steady in strength and direction.
Apparent size	Often somewhat larger than normal Sc, Ac or Cc cloud elements.

ALTOCUMULUS FLOCCUS Ac flo

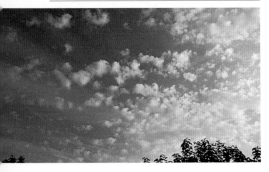

Floccus is a distinctive cloud species. It occurs as altocumulus floccus, shown here, and with cirrus and cirrocumulus. The tufts of cloud often have wispy, ragged bases, or virga. These clouds are an indication of humid air and instability at their level, which is one of the warning signs of possible thunderstorms to come. If cumulus clouds reach that layer, they may shoot up and turn into energetic cumulonimbus.

Appearance	Tufts of cloud, often with ragged bases and sometimes virga (p.84).
Occurrence	In Ac, Cc or Ci.
See also	Altocumulus castellatus (opposite), thunderstorms (p.214).

Altocumulus Castellatus Ac cas

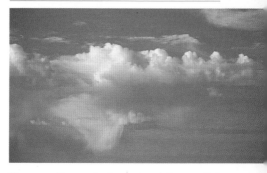

The castellatus cloud species (often called 'castellanus') occurs in altocumulus, shown here, stratocumulus, cirrocumulus and cirrus. Narrow cloud turrets rise from a common base and it is common for these towers to be arranged in lines. Like floccus (opposite), castellatus clouds indicate instability, but in this case the activity is even more vigorous. When altocumulus castellatus are well developed, it is a strong indication that significant thunderstorms may occur within approximately 24 hours.

Appearance	Turrets of cloud, rising from a common base, sometimes in lines.
Occurrence	In Sc, Ac, Cc and Ci.
See also	Instability, thunderstorms (p.214).

67

Altocumulus Stratiformis Ac str

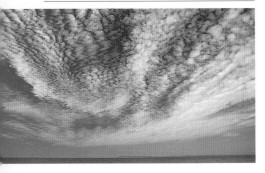

The most common form of altocumulus is an extensive sheet of cloud stretching across most or all of the sky that is called altocumulus stratiformis. The same species is also the most frequent with stratocumulus, but is less often encountered with the higher cirrocumulus. Several different varieties (p.72) may occur, which, with the varied lighting, colours and structure, can produce very interesting and beautiful skies.

Appearance An extensive sheet of cumuliform cloud.
Occurrence In Sc, Ac and Cc.
See also Billows (p.74).

CIRRUS SPISSATUS Ci spi

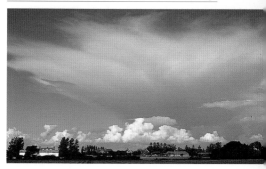

Cirrus is often thin enough to allow the Sun (or Moon) to shine through, perhaps with a halo (p.128) or mock sun (p.130). When cirrus is dense, however, it may appear grey against the Sun (which it may even hide). It is then known as cirrus spissatus. Such thick cirrus is frequently formed at the tops of cumulonimbus clouds, either as part of a plume or anvil.

Appearance	Dense cirrus, appearing grey against the Sun.
Occurrence	In Ci only.
See also	Cumulonimbus incus (p.82).

CIRRUS FIBRATUS Ci fib

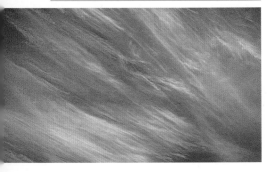

When cirrus has a pronounced fibrous appearance, but is without any obvious tufts or hooks – as in cirrus uncinus (opposite) – it is called cirrus fibratus. Cirrostratus also frequently has a similar appearance. The trails of ice crystals may nevertheless be very long. Occasionally, both in cirrus fibratus and cirrus uncinus, shallow downward bulges (mamma) may be seen, giving the wisps an undulating appearance.

Appearance Cirrus without generating heads or tufts.
Occurrence In Ci or Cs only.
See also Cirrostratus (p.44), mamma (p.83).

CIRRUS UNCINUS

Ci unc

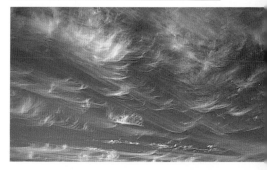

Cirrus uncinus has a highly characteristic hooked shape. Ice crystals are forming at the tip, where there may be a small tuft of cloud. Although the latter is the generating head, it does not have a rounded appearance (if it did, the cloud would be regarded as cirrocumulus with virga). The angle of the hook may be very sharp if there is considerable wind shear just beneath the generating level.

Appearance	Cirrus with a very distinct, hooked tip.
Occurrence	In Ci only.
See also	Cirrocumulus (p.47), mamma (p.83), virga (p.84).

CLOUD VARIETIES

Just as cloud species describe shape and form, varieties define cloud transparency or the arrangement of the individual elements of a specific type. Most of the descriptions are self-explanatory, so only a few varieties are shown individually.

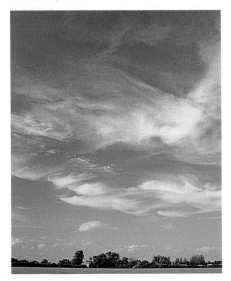

Variety	Abbr.	Description	Cloud Type(s)
Intortus	in	Irregularly curved or apparently tangled	Ci* (opposite)
Vertebratus	ve	Looking like ribs, vertebrae or fish bones	Ci
Undulatus	un	Patches, sheets or layers with parallel undulations	Sc, Ac*, As, Cc, Cs
Radiatus	ra	Broad parallel bands, appearing to converge by perspective	Cu, Sc, Ac, As, Ci
Lacunosus	la	Thin cloud with regularly spaced holes; reticulated (like a net): rare	Ac, Cc
Duplicatus	du	More than one layer, at slightly different levels	Sc, Ac, As, Ci, Cs
Translucidus	tr	Translucent enough to show position of Sun or Moon	St, Sc, Ac, As
Perlucidus	pe	Broad layers or patches, with spaces (occasionally very small) that allow blue sky, Sun, or Moon to be seen	Sc, Ac*
Opacus	op	Completely masks Sun or Moon	St, Sc, Ac, As

* This variety is illustrated

BILLOWS

Wave and stratiform clouds often show a set (or sets) of distinct undulations (variety: undulatus), known as billows. The spaces between individual billows may be completely free of cloud. On other occasions the surface of the layer has regular undulations, or else there are denser rolls embedded in a thinner, more general cloud. Billows always move with the wind, unlike wave clouds themselves. In wave clouds they therefore gradually migrate from the front to the back of the cloud.

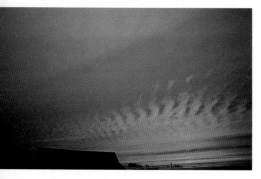

Sometimes the top of a cloud layer has billows that seem to be breaking like waves on a shore. This appearance is often seen on the surface of banks of sea fog or other low cloud. The mechanisms by which billows are produced,

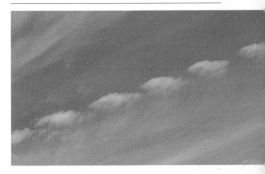

however, are different from true water waves. Most billows are caused by wind shear that occurs when a relatively stable layer is forced to rise. This sets the surface of the layer into a series of oscillations, which become visible as billows. (Similar undulations occur when a layer is forced to descend, but here any billows evaporate in the warmer air.) The billows lie approximately at right angles to the wind direction.

A different process may also cause the layer to develop corrugations, parallel to the wind direction. Sometimes these particular billows are more conspicuous over part, or all, of the cloud. When both mechanisms occur simultaneously, correspondingly complex patterns of billows may result.

ALTOCUMULUS PERLUCIDUS Ac per

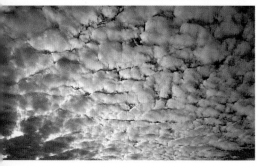

Altocumulus perlucidus is one of the common varieties of altocumulus. The gaps between the cloud elements are large enough (in at least part of the layer) for the blue sky or the Sun to be seen. The structure often arises when convection has begun in a shallow layer of altostratus. When the sheet is illuminated from behind, it is often obvious that some of the apparent gaps do contain very thin cloud.

Appearance	A layer of cloud with distinct lanes of clear sky between the cloudlets.
Occurrence	When convection is beginning to break up a layer of cloud.
See also	Cloud formation (p.94).

CLOUD STREETS

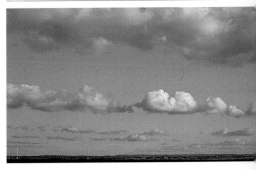

Occasionally, cumulus clouds appear in a long line that stretches downwind. This occurs when a strong source of thermals remains active with a steady wind speed. Several cloud streets, parallel to one another, arise spontaneously when convection is limited by a stable layer (p.98) and wind shear. The spacing between the streets is about 2–3 times the depth of the convective layer. With stronger convection, the streets spread out into stratocumulus (p.28).

Appearance	Cumulus clouds in a distinct line (or lines).
Occurrence	In Cu only.
See also	Cloud formation (p.94).

Accessory Clouds

Certain forms of cloud are not true types in themselves, but always occur in association with one or more of the ten main types. These three 'accessory clouds' are:

- pannus shreds of cloud Cu, Cb, As, Ns (p.79)
- pileus cap cloud Cu, Cb (p.80)
- velum veil Cu, Cb (p.81)

There are also a number of supplementary features, which describe the appearance of particular clouds. They can provide a useful clue to the various processes that are occurring within the clouds. These features are:

- arcus arch cloud (p.215)
- incus anvil cloud (p.82)
- mamma pouches hanging from upper cloud (p.83)
- praecipitatio precipitation reaching the surface (p.142)
- tuba funnel clouds of any type (p.227)
- virga fallstreaks (p.84)

PANNUS

Pannus is an accessory cloud that consists of two ragged cloud species, cumulus fractus (p.60) and stratus fractus (p.61). It is commonly called 'scud' by sailors. It may occur as a distinct layer beneath (and separate from) other clouds or it may be attached to them.

Pannus generally appears darker than the main cloud, but is often difficult to distinguish when looking vertically. With cumulus or cumulonimbus it is often visible against the lighter sky seen beneath the cloud.

Appearance	Dark shreds of cloud beneath the main cloud type.
Occurrence	In association with Cu, Cb, As or Ns.
See also	Cumulonimbus (p.48).

79

PILEUS

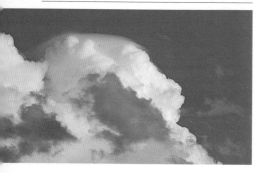

Pileus – sometimes called a cap cloud – is a smooth cloud that appears above cumulus or cumulonimbus when the rising thermals lift a stable, and previously invisible, humid layer of air above its condensation level. It looks like a miniature wave cloud (p.64) until the rising thermals reach it and it is mixed into the cumulus. Occasionally, a temporary collar remains round the cumulus tower, but eventually the pileus subsides and disappears. When there is strong wind shear, pileus may lie downwind of the rising thermals.

Appearance A smooth, short-lived cap of cloud above cumulus or cumulonimbus.
See also Velum (opposite).

VELUM

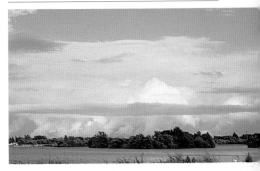

Velum is an accessory cloud that appears as a thin, widespread sheet associated with the tops of cumulus or cumulonimbus. These generally rise through it, however, and often well above it. Because it is usually at a lower level and in shadow it may appear very dark, in contrast to the brilliantly illuminated cloud above. It is a stable, humid layer of air, which, unlike pileus, remains visible for a long time, sometimes persisting even after the cumuliform cloud has decayed.

Appearance A thin, often dark, sheet of cloud accompanying cumulus or cumulonimbus.

See also Pileus (opposite).

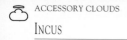
INCUS

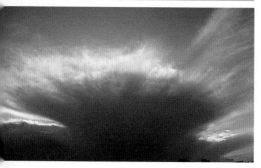

Cumulonimbus incus have a characteristic anvil shape where they have spread out under an inversion, often at the tropopause. The updraughts within vigorous storms are so strong that many anvils extend a considerable distance upwind.

Anvils sometimes look smooth, but generally ice crystals give them a fibrous or striated appearance. Occasionally, they may persist when the rest of the cloud has disappeared, and remnants may linger for days as disorganised cirrus.

> **Appearance** Flattened anvil tops to cumulonimbus.
> **Occurrence** When cumulonimbus reach an inversion.
> **See also** Thunderstorms (p.214).

MAMMA

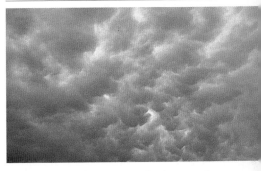

Rounded pouches sometimes develop on the underside of clouds. These are known as mamma and commonly occur beneath overhanging cumulonimbus anvils, and also with various other cloud types. They arise when cool, moist air subsides from the cloud, while slightly drier, clear air rises in the intervening spaces. The shape may vary from almost spherical masses, long, contorted tubes or a series of ridges (under cumulonimbus anvils), to a shallow, scalloped effect (in cirrus trails).

Appearance	Rounded pouches hanging from higher cloud.
Occurrence	Beneath Cb, Sc, Ac, As, Ci and Cc.
See also	Virga (p.84).

VIRGA

Virga (or fallstreaks) are a common feature of clouds. They are trails of falling water droplets or ice crystals that evaporate before they reach the ground. Although often hook-shaped, this is not always a sign of wind shear, because as the particles descend and evaporate, their fall speed decreases, so they are left progressively farther behind. Cirrus frequently consists of nothing but virga, which also often give a striated look to the heads of cumulonimbus capillatus (p.63).

Appearance	Trails of precipitation that do not reach the ground.
Occurrence	Beneath Cb, Sc, Ac, As, Ci and Cc.
See also	Precipitation (p.142).

FALLSTREAK HOLES

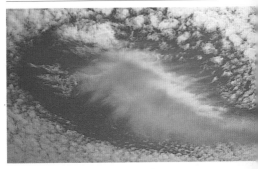

It is not uncommon for isolated, apparently regular holes to appear in thin sheets of cloud. Although often reasonably symmetrical, on occasions almost perfect circles have been seen. They appear when freezing is initiated in thin cloud. The crystals fall out – and are often visible as virga or cirrus wisps below the cloud – leaving the hole. Aircraft can produce similar dissipation trails (or distrails), but the exact cause of the extreme regularity sometimes seen is often obscure.

Appearance	Symmetrical (or nearly symmetrical) holes in thin cloud sheets.
Occurrence	In Ac, As, Ci and Cc.
See also	Virga (p.84), contrails (p.86).

Contrails

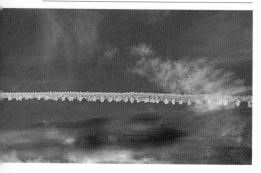

Condensation trails, or contrails, are a familiar sight. They are lines of cloud that have formed from the water vapour emitted by aircraft engines. Initially the exhaust is very hot and the water vapour is invisible, so there is a clear gap behind the engines. Farther away (at about twice the aircraft's wingspan), mixing cools the exhaust sufficiently for condensation to occur.

The duration of contrails depends on conditions at that altitude. If the air is dry and relatively warm, trails evaporate and fade very quickly. If the air is cold, the water droplets freeze into ice. Such trails may be extremely persistent and last for hours. When conditions are suitable, they may even spread into a sheet of cloud that covers the sky.

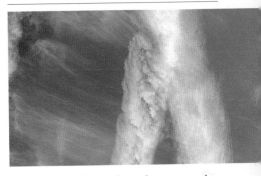

The structure of contrails may be quite complex. All aircraft produce a large, invisible vortex that trails behind each wing-tip. The exhaust gases are drawn into the centres of these vortices, where the lowered pressure assists in the condensation process. The twin rolls of cloud that result may persist longer than the rest of the contrail.

The air behind an aircraft is forced downward – that is what keeps the aircraft up – but it is also heated by the exhaust, so there is a tendency for it to rise. The net result is a vertical curtain of cloud. At the same time the vortices develop loops, and the trail begins to break up and evaporate, unless it has frozen, when it behaves like cirrus.

The ice crystals in glaciated (frozen) contrails are frequently all of the same size. They may

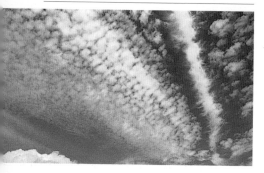

therefore give rise to mock suns (p.130) with extremely bright, pure, spectral colours.

The downwash from an aircraft may affect thin cloud that lies just beneath the flight path. Apart from heating caused by the exhaust, dry air from above the cloud may be mixed into it. The result may be a dissipation trail (or distrail), which is a clear lane cut in the cloud. Sometimes the invisible, descending loops create a line of holes in the sheet of cloud. On other occasions, the aircraft initiates freezing in the cloud. The ice crystals then fall out, and so a distrail occurs above a frozen contrail, like a linear fallstreak hole (p.85).

The shadows of contrails may sometimes cause confusion. When cast onto very thin cloud, they may look almost exactly like a true distrail.

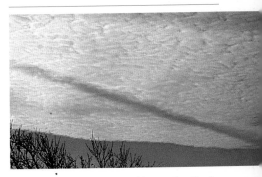

Usually, however, it is possible to identify the contrail itself. Depending on the angle of the sunlight this may be a considerable distance away. Often more than one contrail is present, and their shadows can give a clue as to the relative altitudes at which the different aircraft are flying.

Contrail shadows are often visible from the aircraft that is creating them. Occasionally, you may see a glory (p.125) surrounding the head of the shadow. From the ground, very long, dark virga have sometimes been confused with shadows, but normally closer examination soon reveals their true cause.

CLOUDS FROM THE AIR

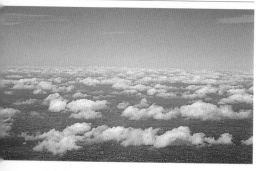

A flight in any aircraft offers an ideal opportunity to study clouds from a different viewpoint, which helps to understand their three-dimensional structure. It also gives a better idea of the heights of different clouds, particularly during the ascent and descent. The cruising altitudes of most long-haul flights (30,000 ft or slightly more than 9 km) are above all but the highest clouds.

The ideal conditions for a smooth flight would be very stable conditions (p.98), with no convection. It is the latter that tends to produce the bumpiness often experienced at the beginning and end of flights. In general, higher levels are more stable, although wind shear – especially near jet streams – may produce clear air turbulence.

On take-off and landing under very humid

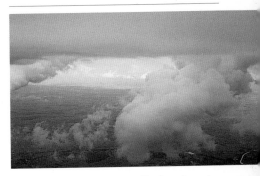

conditions you may notice trails of condensation
from wing-tips or other parts of the aircraft. This
condensation is a sign of localised low pressure
(and resulting lower temperatures). The trail from
each wing-tip lies at the core of the large, and
otherwise invisible, vortex that it creates (p.87).
Propeller aircraft show similar trails from the tip of
each blade.

All modern aircraft are pressurised. When flying
at altitude the outside air is very cold and
consequently very dry. When it is compressed and
heated before being introduced into the cabin, its
humidity is reduced even further. This is why, on
long flights, it is important to drink enough fluid to
prevent your body from becoming dehydrated.

Glider pilots report that the apparently flat base

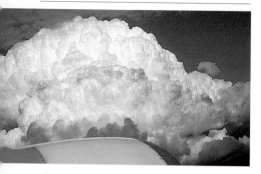

of cumulus clouds is concave, being slightly higher in the centre. This is difficult to detect from fast-moving jets, but when you are close to clouds you can easily see the difference between hard, growing cells and the softer outlines where cumulus are beginning to evaporate. Similarly, the differences between clouds that consist of water droplets and those where glaciation (freezing) has begun are more apparent than when observing them from the ground.

Most flights avoid cumulonimbus clouds and thunderstorms because of the extreme turbulence that may be encountered within them. The elevated (and moving) viewpoint often enables you to obtain a clear idea of a storm and its associated flanking line (p.216) that might be hidden from the ground.

Haze (p.104) is immediately apparent from the air and is the main reason why photographs are often disappointing, unless the air mass is particularly cold and clear. (With black and white films, a light yellow filter will help to increase contrast.)

Which is the best side of the aircraft for observing the sky? In general, it is probably the one away from the Sun. Here, you are less subject to glare and can see more detail. Glories (p.125), rainbows and contrail shadows may also be visible. On the other side, however, there are often interesting sun-glint effects from bodies of water, and you may be lucky enough to see certain rare halo phenomena, particularly the bright, elliptical spots of light below the Sun's position (called sub-suns) when flying in ice-crystal cloud.

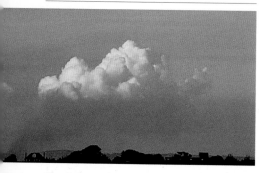

Clouds form when air cools to the dewpoint, the temperature at which air becomes saturated and the previously invisible water vapour condenses into tiny droplets. Cooling occurs in two basic ways: air either comes into contact with a cold surface, or rises in the atmosphere. The first process occurs when moist air passes over cold land or sea to give low stratus cloud (p.26) or fog (p.150).

Air may rise when:

- there is convection caused by heating
- it is forced over hills or mountains
- it encounters colder, denser air

Another process, convergence, occurs when air is forced into a restricted area. Some of the air must rise to escape.

Convection is very familiar and occurs when any

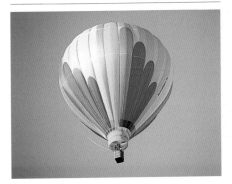

gas or liquid is heated from beneath. In the atmosphere, it is responsible for most of the pressure differences (p.162). Above ground heated by the Sun, or other sources of heat such as fires, invisible bubbles of warm air (thermals) break away from the surface like a series of hot air balloons.

The thermals expand and cool as they rise, and eventually reach the dewpoint. The type of cloud that forms depends entirely upon the way in which the temperature of the surrounding air varies with height (p.96), and upon whether the air is stable or unstable (p.98). Convection generally produces cumuliform (p.22) clouds, but may produce stratocumulus and altocumulus – intermediate types that have some stratiform features.

INVERSIONS

In the lowest region of the atmosphere, the troposphere, temperature tends to decline with height. Taken overall, the rate at which the temperature falls, called the lapse rate, averages about 6°C per km. This rate is not constant, because the air actually consists of various layers of different temperatures and humidities. In certain layers, known as inversions, temperature increases with height.

A major inversion, called the tropopause, defines the boundary between the troposphere and the overlying stratosphere. Above the tropopause, temperature increases markedly throughout the stratosphere, up to about 50 km. (The temperature mainly rises because ozone, in the ozone layer within the stratosphere, absorbs a large amount of energy from ultraviolet radiation emitted by the Sun.)

The tropopause height depends on latitude and season (as well as other factors), but is at about 16–18 km over the equator, 11–12 km at middle latitudes, and 8–9 km over the poles.

The tropopause frequently limits the growth of the most vigorous cumulonimbus clouds, and forces them to expand sideways into large cirrus anvils. It should not be regarded as an absolute barrier, however, because there are important breaks where the level changes abruptly, and mixing occurs between the troposphere and stratosphere. These breaks generally occur where there are the largest temperature gradients, such as near the polar front

and the subtropical high-pressure zones (p.172). Jet streams also tend to lie close to these points.

Air conducts heat poorly. Once away from the surface, a parcel of air cools or warms almost independently of its surroundings. The rate at which rising air cools depends on the amount of water vapour present. All air contains water vapour, but when it is above its dewpoint no water droplets are present and it is described as 'dry'. Dry air cools at about 10°C per km.

Because heat is required to evaporate water (or melt ice), the reverse process, condensation (or freezing), releases this latent heat. Once air has cooled to the dewpoint, cloud droplets form and the heat released reduces the rate of cooling. As a result, saturated air cools at a lower rate – about 4.5–5°C per km.

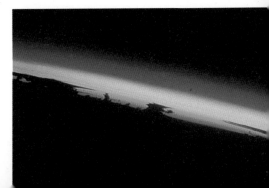

STABILITY AND INSTABILITY

Warm air rises, expands and cools (at a standard rate, see previous page). How far a freely rising parcel of air rises and whether it comes to a stop depends on the surrounding air. If this is relatively warm it has a lower lapse rate, so the rising air cools faster than its surroundings. When the rising air reaches the same temperature as the surroundings it comes to a halt. If it rose farther it would cool more, becoming colder than the surroundings, and thus sink back. Such conditions are said to be stable, and lead to the formation of stratiform clouds if the rising air does reach the dewpoint.

If, on the other hand, the surrounding air is relatively cold, it has a high lapse rate and cools rapidly with height. A rising parcel of air, despite its own expansion and cooling, may remain surrounded by colder air and thus continue to rise. The conditions are unstable, and result in cumuliform clouds. The rising air may even accelerate, especially if it reaches the dewpoint and condensation occurs. The release of latent heat from the rising air increases the temperature difference, so the parcel of air rises even faster.

Instability (and cumulus clouds) are often found in cold air flowing over a warm sea. Warm air moving over cold land, by contrast, is stable and frequently produces low stratus cloud. An inversion is a layer where temperature increases with height, so inversions are layers of extreme

stability. They often cause the upward growth of clouds to come to a halt.

Cloud forms when a parcel of air rises, cools and reaches its dewpoint. This establishes the height of cloud base. The vertical extent of the cloud will depend on the stability. If the lapse rate of the surroundings is low (stable conditions), the air, although cooling at the saturated rate, will soon reach the surrounding temperature and cloud growth will stop. Shallow, stratiform clouds result.

If the lapse rate is high (unstable conditions), once a parcel of air reaches the dewpoint, it will rise rapidly and may not be checked until it reaches the tropopause. Cumulus and cumulonimbus clouds imply that the atmosphere is unstable.

Stratocumulus and altocumulus often arise when cumulus clouds encounter an inversion.

Orographic Clouds

Clouds formed by forced uplift over hills or mountains are known as orographic clouds. The cloud type depends upon the prevailing stability. Stable conditions produce stratiform cloud. Over low hills this is normally stratus (or 'hill fog').

Just as air cools when it rises, it also warms at the same rates (10°C per km for dry air and 4.5–5°C for saturated) when it descends. On the sheltered side of hills or mountains, cloud droplets evaporate and any cloud tends to break up and disperse.

With the right combination of stable conditions, wind speed and direction, trains of waves may be set up, with lenticular clouds (p.64) in the crests. Such waves may bring air down from upper, warmer levels in the shelter of mountains.

Such descending air may be much warmer and dryer than air at the same height on the windward side. The sudden onset of this 'föhn effect' may

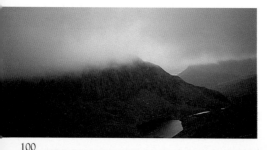

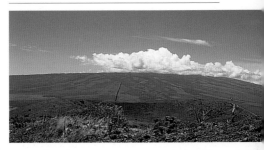

cause a dramatic temperature rise accompanied by extremely dry air and the rapid disappearance of any lying snow.

When conditions are unstable, cumuliform clouds obviously form. In the intermediate case, conditional instability, the uplift provided by the hills may be enough to trigger cloud formation and growth. Either may produce substantial rainfall over the hills. Conditional stability may occur when dry, stable air is forced to rise (e.g. by uplift over hills). If it becomes saturated, the release of latent heat enables it to continue rising, triggering cloud formation and growth.

In the final process of cloud formation, cold air lifts warm air away from the surface. This occurs at the warm and cold fronts of depressions (p.196). The former tend to produce stratiform clouds, and the latter cumuliform as well.

BLUE SKY

The blue of the sky arises because the atmosphere consists of various gases (mainly nitrogen and oxygen). The molecules of gas scatter light from the Sun in all directions, and affect blue and violet light (which have the shortest wavelengths) much more strongly than other colours. This scattered light reaches our eyes, which, being insensitive to violet, only detect the blue. This overwhelms the small amounts scattered at longer wavelengths, so in general, wherever we look the sky appears blue.

The depth of colour largely depends upon the amount of water vapour (and dust particles) in the air. These scatter light of other wavelengths as well. This is why, high in the mountains or flying in an aircraft where the air is dry, the sky is deep

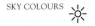

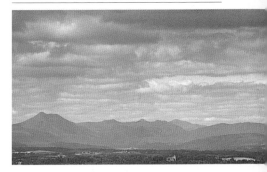

blue, but lower down the air is more humid and the sky is much paler. At low levels, the deepest blue often occurs in the dry, clean air behind a cold front whose rain has washed the dust particles from the air. Such conditions also give the best visibility.

Because air is rarely completely dry, even in the absence of dust or pollutants, scattering causes distant objects to appear paler, bluer and less distinct than nearer ones. Such aerial perspective is always present and is one of the methods that we use (subconsciously) to judge distances. It is readily visible when looking at a range of mountains, where the farther ridges gradually fade away into the blue distance.

See also Sunset sky colours (p.108) and haze (p.104).

HAZE

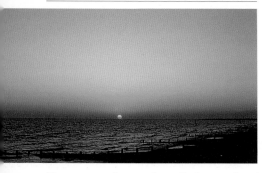

Haze consists of extremely small, dry particles of smoke or dust that reduce horizontal visibility. It generally lessens contrast and subdues all colours. The particles are so small that they tend to scatter the shorter wavelengths. This produces a bluish colour when seen against a dark background, and a yellowish or brown tinge when seen against the light. Haze is frequently trapped under an inversion especially when anticyclonic conditions (p.210) prevail.

Appearance	A bluish or yellowish veil that reduces horizontal visibility.
Occurrence	Particularly prominent when still conditions and an inversion limit dispersion of haze particles.
See also	Mist and fog (p.150).

ATMOSPHERIC DUST

Dust may cause a number of effects. If the particles are of a uniform size, they may selectively remove light of specific wavelengths. After volcanic eruptions or major dust storms this may produce a blue (or green) Moon or Sun.

After particularly violent volcanic eruptions, dust high in the atmosphere produces distinctive orange colours long after sunset. Weak undulations are often visible approximately at right angles to the direction of sunlight.

Appearance	Blue (or green) Moon or Sun; orange streaks visible long after sunset.
Occurrence	After major dust storms or volcanic eruptions.
See also	Purple light (p.109).

LOW SUN AND SKY COLOURS

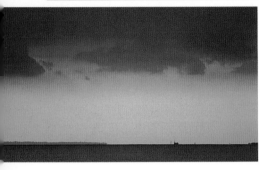

Whenever sunlight has to take a long path through the atmosphere, its colour changes. The shorter wavelengths are weakened by increased scattering, and the light may turn greenish, yellow, orange, or even red. If there is an extensive bank of thick cloud blocking direct sunlight and surrounded by clear sky, the sky beneath the cloud often appears to have a striking orange hue. A green shade is uncommon, but not unknown, especially when rain is present, while blue-green may indicate hail.

As the Sun sinks towards the horizon at sunset, its light also takes a longer path through the atmosphere, hence the fact that the setting Sun becomes orange or red. (Conversely, at sunrise the red or orange colour fades away.) A blue or

green Sun is rare, unless there is dust in the atmosphere (p.105). If a layer of haze (p.104) has built up during the day, it also affects the colour of the Sun.

Close to the horizon, the Sun often appears flattened, and if there are various layers of air of different densities (which refract the light by different amounts) its outline may appear ragged. Sometimes, when the conditions produce a mirage (p.136), the Sun is highly distorted and may assume very strange shapes. Occasionally, when the air is very clear and free from any form of haze, the last segment of the Sun to disappear flares green. This is the famous 'green flash', which is most likely to be visible over the sea. A similar blue flash has also been seen.

SUNRISE AND SUNSET SKY COLOURS

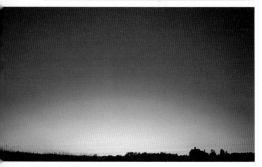

Apart from the Sun, the sky itself goes through a complex pattern of changing colours at sunrise and sunset. These colours are strongest at sunrise, before any haze is present. Under normal conditions, after the Sun has set, the sky immediately above that point is a pale yellow, with a blue-white arch above. To either side, the horizon sky is orange, with yellow above that.

A little later, the twilight arch above the sunset point becomes salmon-pink, with yellow and orange lower down. The pink area gradually flattens, as the sky higher above darkens from blue-grey to purple-blue and finally a dark blue. The final glimmers of light on the horizon are often greenish-yellow, with blue shading to a deep blue overhead.

PURPLE LIGHT

Occasionally, instead of the normal salmon-pink tinge, the twilight arch takes on a vibrant purple colour. This is quite distinctive, but is almost impossible to photograph and reproduce, because of the limited response of colour films.

This effect occurs only after powerful volcanic eruptions have blasted dust and sulphur compounds into the upper atmosphere. There, the materials scatter additional red light, which combines with the normal blue light to produce the strong purple hue.

Appearance	A bright, vibrant purple glow at the top of the twilight arch, 20–30° or more above the horizon.
Occurence	Only after the most powerful volcanic eruptions, and best seen when the lower atmosphere is particularly clear.
See also	Low Sun and sky colours (p.106), haze (p.104), atmospheric dust (p.105).

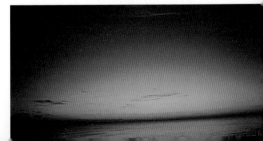

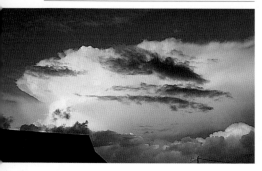

Sunlit clouds show every shade from brilliant white to almost black. In dense clouds there are vast numbers of tiny droplets in any given volume. They scatter light of all wavelengths so effectively that very little light penetrates into the clouds themselves. Most is reflected and scattered back towards the source and any observer. So the clouds appear bright.

Larger droplets absorb more light. In old clouds that have begun to disperse, the tiny droplets evaporate first. There is also a low droplet density per unit volume. Light not only penetrates more deeply, but is strongly absorbed. The clouds thus appear dark, particularly if they are seen against bright clouds in the background. This effect also accounts for the dark edges seen around some clouds.

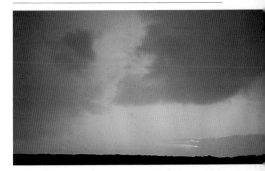

The presence of ice, particularly snowflakes, in the top of a cloud not only produces a fibrous appearance, but also subtly alters the colour. Generally, the clouds do not seem quite as bright. Similarly, there are differences in the appearance of rain (which appears dark) when compared with snow and hail (which appear brighter).

If the main source of light is the blue sky, rather than direct sunlight, the clouds take on a corresponding blue tint. This can often happen when the sky is full of large cumulus clouds that prevent sunlight from illuminating nearby clouds. Similarly, the base of low clouds may reflect the colour of the surface beneath. This effect may be particularly noticeable over seas or lakes, or bright, strongly coloured, desert sands.

 CLOUD COLOURS

Sunset Cloud Colours

At sunset (and sunrise), cloud colours may change dramatically in a short time. This is particularly the case when there are various layers of broken cloud, some of which may be in shadow, while others are illuminated by direct sunlight. Under such conditions, clouds may appear grey at one moment and brightly coloured the next. It is generally these colours, rather than those of the sky background, that people have in mind when they speak of a 'fine sunset'.

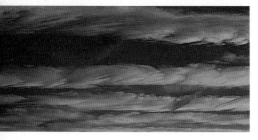

The cloud colours are generally the same as that of the sunlight that is illuminating them, which shifts from yellow to red as the Sun descends. Other hues sometimes result from mixing with blue or purple light from the sky itself.

See also Low Sun and sky colours (p.106), purple light (p.109), crepuscular rays (p.116), earth shadow (p.115).

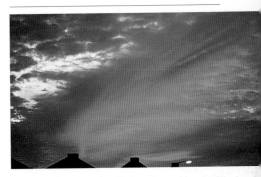

The most striking effect occurs when high cumulus or cumulonimbus clouds lie on the opposite side of the sky to the Sun, in a clear sky. Their tops then glow with a brilliant red light. When snow-covered mountain tops are illuminated in this way – the deeper slopes being in shadow – it is known as alpine glow. This effect is sometimes called the counterglow, but this term is better reserved for the coloured band seen at the edge of the Earth's shadow (p.115).

The low angle of illumination produced by the rising or setting Sun may cause cloud features that otherwise are difficult to see to stand out in bold relief. This is particularly the case with the mamma (p.83) that occur beneath overhanging cumulonimbus anvils.

Mountain Shadow

The shadow of a mountain at sunset or sunrise appears as a dark cone stretching towards the opposite horizon. The shadow may be seen when the sky is clear, but is usually even more striking when it falls upon a layer of lower clouds. The appearance is always the same, regardless of the mountain's actual profile. In fact, the sides of the shadow are parallel and merely appear to converge (because of perspective), just like the sides of a road or a line of telephone poles and wires.

Appearance	A dark 'cone' of shadow, stretching towards the horizon.
Occurrence	When the observer is in full sunlight immediately before sunset (or after sunrise).

EARTH SHADOW

As the Sun dips below the horizon in the west at sunset, a blue-grey arc, bordered by a soft reddish band (known as the counterglow), rises in the east on the opposite side of the sky. This is the shadow of the solid Earth itself, cast onto the lower atmosphere. As time passes and it rises into the sky, the shadow becomes darker and the edge less distinct, until it eventually merges into the darkening sky above. A similar shadow sinks towards the western horizon at sunrise.

Appearance A steel-grey band, edged with red, seen on the opposite side of the sky to the rising or setting Sun.

Occurrence Only when the sky is clear to the horizon in both east and west.

CREPUSCULAR RAYS

Crepuscular rays are shafts of light or shadow that appear to radiate from a single point in the sky. Although they are named after their appearance at twilight, they occur at all times of the day. Three forms are recognised:

- rays of light penetrating holes in low cloud
- beams of light diverging from behind a cloud
- pale pinkish rays that radiate from below the horizon

All three types tell us something about the transparency of the atmosphere. In the first case – sometimes known as 'the Sun drawing water' or 'Jacob's ladder' – the rays are similar to sunbeams seen in mist, and are caused by scattering by water vapour or dust particles. Such rays are often visible through breaks in cloud cover and have occasionally been mistaken, at first glance, for shafts of rain.

Appearance	Rays of light or shadow radiating from clouds or from below the horizon.
Occurrence	When the atmosphere contains otherwise invisible mist or haze.
See also	Haze (p.104), mountain shadow (p.114).

In the second type, pale rays diverge upwards from the Sun when it is hidden behind a cloud, which is usually a cumulus or cumulonimbus, but may be of another type. Depending on circumstances, the light rays or dark shadows may be most prominent.

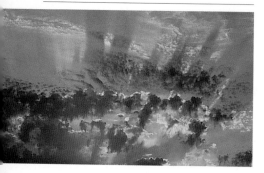

Again, these rays only arise when the air is humid or contains fine dust. They sometimes provide a useful indicator of the position of the Sun.

The third form opposite is probably the most interesting. At sunrise and sunset, pale rose-coloured rays appear to radiate from a point below the horizon. The pinkish colour is caused by scattering from haze particles. The corresponding shadows may sometimes appear to have a slight green tinge. On occasions, the shadows themselves may be the most prominent feature, seen against a general, diffuse pinkish tint to the sky. The shadows are cast by distant clouds or (sometimes) mountains.

Occasionally, breaks in the cloud cover may cause rays of light to shine on the bottom of a layer of clouds. A single, vertical ray of this type could be

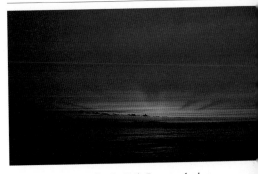

mistaken for a sun pillar (p.134). Because the latter may be seen only in thin, ice-crystal cloud, a consideration of cloud type will soon show which effect is most likely.

In all three types, the rays are actually parallel, and the apparent divergence is simply caused by perspective. Rays of the second and third types may sometimes extend right across the sky, and converge to the antisolar point, directly opposite the Sun. When the Sun is below the horizon, the antisolar point is above it. The rays – sometimes called anti-crepuscular rays – therefore appear to converge at a point some distance above the horizon.

RAINBOWS

Rainbows are not often confused with other optical effects, although very short portions of a rainbow are sometimes mistaken for brightly coloured mock suns (p.130). Although normally associated with rain, similar bows may be seen in the spray from waterfalls, fountains or vehicles. Sunlight consists of a mixture of different wavelengths, which the droplets disperse by different amounts, giving rise to the familiar spectrum of colours. The drops also reflect the light, so rainbows are always on the opposite side of the sky to the Sun.

The bow is part of a circular arc, centred on a point in the sky (the antisolar point) directly opposite the Sun. Under perfect conditions (such as from an aircraft) it should be possible to see a complete circle. When just part of an arc is visible, it may mean that there is no rain or spray in that direction, or that the droplets are not in sunlight.

Appearance	A portion (or portions) of one or more circular arcs, normally brightly coloured, but sometimes showing a single colour.
Apparent size	Primary bow has a radius of 42°, secondary bow, 52°.
See also	Sunrise and sunset sky colours (p.108).

The most common bow (the primary bow) is 42° in radius, with red on the outside and violet on the inner edge. Larger, secondary bows with a radius of 52° are often seen, and their sequence of colours is

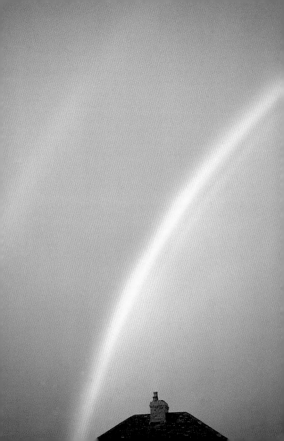

reversed, with red on the inside. The region between the bows is known as Alexander's dark band. It is normally much darker than the sky inside or outside the bows, because the raindrops deflect light away from the observer's eyes. Pale, violet-pink arcs, known as supernumerary bows, sometimes appear just inside the primary bow.

The height of the top of a rainbow depends on the Sun's altitude: the lower the Sun, the higher the arc. So the height of rainbows varies throughout the day and with the season of the year. If there is a sheet of water behind the observer, the

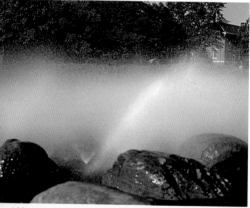

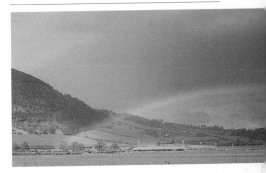

Sun's reflection may be bright enough to act as a secondary light source. It is then sometimes possible to see a higher, reflected rainbow together with the ordinary bow (or bows).

The brightness of the colours depends on the size of the water droplets. Large drops give bright colours and the red is particularly prominent. With smaller drops, the outermost colour tends to appear orange. With extremely tiny drops, like those in fog, all colour disappears leaving a white arc known as a fogbow.

The visible colours are also affected by the colour of the sunlight. When the Sun is just rising or setting, the bows are red, because only red light remains after passing through the atmosphere (p.106).

CORONA

A corona is a coloured ring (or rings) of light surrounding the Sun or the Moon, seen through medium or high cloud. The shape may change as clouds pass across the Sun. Do not confuse a corona with a halo, which is much larger. Generally the colour is bluish near the centre, then white, and reddish brown on the outside. Any additional outer rings usually show a different range of colours.

Appearance	Coloured ring (or rings) around the Sun or Moon, reddish brown outside. Actual colours vary.
Apparent size	Much smaller than 22° halo (p.128), but the diameter varies. Shape alters as clouds pass across the Sun.
Occurence	In Ac, As and sometimes other clouds.
See also	Iridescence (p.126).

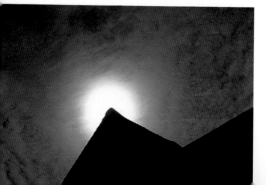

GLORY

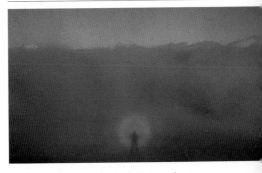

A glory is a series of coloured rings that appear around the antisolar point. The inner rings are generally complete, but larger rings or partial arcs are sometimes also visible. Although most commonly seen nowadays from an aircraft (p.93), on a mountain you may see it around the shadow of your own head (not those of companions) that is cast by the Sun onto a nearby mist- or cloud-bank. If your shadow seems magnified, the effect is known as the Brocken Spectre.

Appearance	Coloured rings around the shadow of the observer's head.
Occurrence	Seen from hills or aircraft against any water-droplet cloud.
See also	Corona (p.124), iridescence (p.126).

IRIDESCENCE

Iridescence appears as a series of coloured bands in thin clouds, particularly altocumulus and altostratus. The colours may be similar to those in a corona, but frequently show beautiful pastel shades. Unlike coronal colours, iridescence may appear much farther away from the Sun (or Moon).

These coloured bands are often missed: see Watching the Sky (p.10) for hints about detecting them. They are, in fact, very common, and can often be discovered at the edges of any clouds that pass across the Sun.

The colours in iridescence (and in a corona), arise through a process called diffraction: light bends round water droplets or ice particles, rather than passing through them as in rainbows or halo phenomena. The light recombines to give the

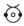

various colours (called interference colours), like those seen in oil on a road. The different colours show where the water droplets or ice particles are all the same size.

Appearance	Coloured bands around the edges and within clouds. Pastel colours are frequently seen.
Occurrence	In many clouds, but often prominent in thin Ac and As.
See also	Corona (p.124), glory (p.125).

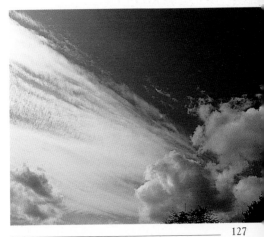

HALOES

Haloes are far more common than most people realise. They are produced by thin ice-crystal cloud, particularly cirrostratus, that has very little effect on the strength of sunlight reaching the ground, so often goes unnoticed. If the sky becomes slightly milky in appearance, especially if there are signs of streaks of cirrus, it is worth checking for a halo. If you hide the brilliant disc of the Sun behind some suitable object, a ring of light may appear, centred on the Sun itself. (Similar haloes also occur around the Moon.)

Dozens of different optical effects are grouped together as halo phenomena. True haloes may look colourless to the eye, but they are coloured, with red towards the inside and violet outside. They may be accompanied by other shorter arcs, some of which are strongly coloured, and various bright images of the Sun (known as mock suns).

Appearance	A ring (or portion of a ring) of light, centred on the Sun (or Moon), faintly coloured with red inside.
Apparent size	The radius of the most common halo is 22°. A larger, somewhat fainter halo, 46° in radius, is occasionally seen.
Occurrence	Only in ice-crystal clouds, usually Cs, but occasionally in Ci and Cc, when partial haloes are common.
See also	Mock sun (p.130), circumzenithal arc (p.132).

128

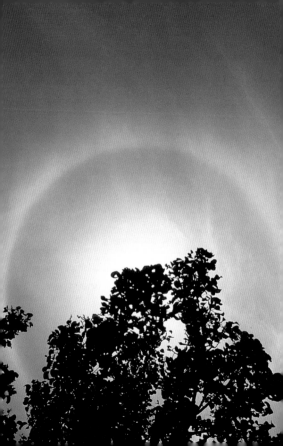

MOCK SUNS

Mock suns are bright spots of light at the same height above the horizon as the real Sun. They often resemble bright patches on the 22° halo. Mock suns may appear in patches of cirrus cloud when no halo is visible. Many are strongly coloured, with red always on the side towards the Sun. There may also be a bright, white 'tail' pointing away from the Sun. The technical name for mock sun is parhelion.

When ice crystals floating in the air have random orientations they give rise to a circle of light: a halo. If the top and bottom faces lie horizontally, light that passes through them is concentrated in two bright spots (the mock suns) on either side of the Sun. When the Sun is high, the mock suns lie slightly outside the 22° halo and seem higher than the true Sun.

The same effects are observed with the Moon, so

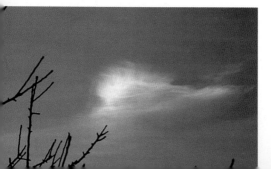

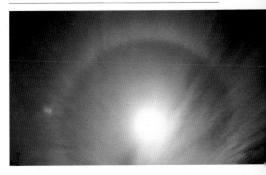

there are also lunar haloes and mock moons. As with coronae, it is often easier to see these optical effects around the Moon, because the eyes are not so dazzled as they are with light from the Sun.

Appearance	Bright spots of light, at approximately the same altitude as the Sun (or Moon), sometimes strongly coloured with red on the inside.
Position	Often on the 22° halo, but a short distance outside when the Sun is high in the sky.
Occurence	Only in ice-crystal clouds, frequently seen without haloes in Ci and Cc.
See also	Haloes (p.128), circumzenithal arc (p.132), parhelic circle (p.133).

131

CIRCUMZENITHAL ARC

A circumzenithal arc is a bright band of spectral colours, part of a circle centred on the zenith, the point directly above the observer's head. Unlike haloes and mock suns, where only red and orange are distinct, green and blue are usually also present.

A circumzenithal arc lies just outside the 46° halo, but because the latter is uncommon, the two are not often seen together. This arc cannot occur if the Sun is more than 32° above the horizon.

Appearance	A brilliantly coloured arc of light above the Sun, part (often about one-third) of a circle centred above the observer.
Position	Just outside the 46° halo, sometimes visible at the same time.
Occurrence	In ice-crystal clouds; Sun's altitude below 32°.
See also	Haloes (p.128), mock suns (p.130).

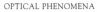

PARHELIC CIRCLE

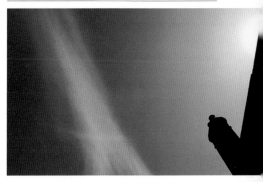

The parhelic circle is a faint white ring that sometimes runs right around the sky, at the same altitude as the Sun. It is caused by ice crystals with vertical faces that reflect the sunlight. It is rare, and generally only part of the circle is seen.

Do not confuse the tails of mock suns with the parhelic circle. Mock suns are normally much brighter and taper away from the Sun. Only the parhelic circle is ever seen inside the 22° halo.

Appearance	A faint white ring of light sometimes stretching right round the sky.
Position	At exactly the same altitude as the Sun.
See also	Haloes (p.128), mock sun (p.130), circumzenithal arc (p.132).

133

SUN PILLAR

A sun pillar is a vertical streak of light immediately above or below the Sun (or both). Like the parhelic circle, it is produced by sunlight reflected from ice crystals, but from nearly horizontal faces. Around sunrise or sunset it may be orange or red like the sunlight, but at other times it is white. On rare occasions, both a sun pillar and the parhelic circle may be seen simultaneously, forming a cross in the sky, centred on the Sun.

A sun pillar tends to be easier to see when the Sun is low (and not so bright), or partially hidden by clouds. If there are clouds low on the horizon, crepuscular rays or a shaft of light that strikes the underside of a layer of clouds may sometimes resemble a true sun pillar.

Appearance	A vertical streak of light above or below the Sun.
Position	Always vertical to the horizon and through the Sun, never elsewhere.
See also	Haloes (p.128), parhelic circle (p.133), crepuscular rays (p.116).

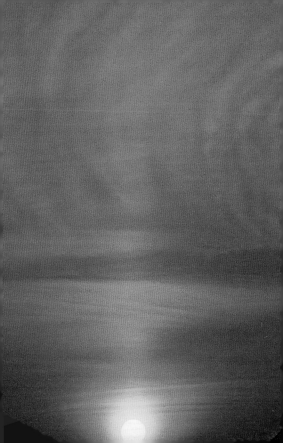

MIRAGES

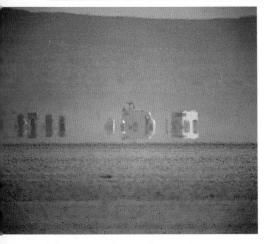

Mirages occur whenever there is a sharp temperature gradient in the air. This may occur over either a hot or a cold surface. In both cases, mirror images may be produced, objects may seem elongated, or be so distorted that they cannot be recognised.

There are two types of mirage, distinguished by where the objects appear relative to their normal positions:

- inferior mirage objects appear lower
- superior mirage objects appear higher

The most common mirage is the 'pool of water' seen on a hot road. This is an inferior mirage, because the 'water' is actually an image of the sky. Rays of light from the sky that would not normally reach the eye are refracted upwards by the hot air close to the road, so they seem to come from a lower point than normal. We interpret this as a 'reflection' of the sky in a pool of water.

A similar effect occurs when the surface layer is cold and higher levels are warm (i.e. when there is an inversion). In this case we have a superior mirage, and may appear to be looking over the horizon. (This is known as 'looming' to sailors.) Complex layering may give multiple, distorted images.

Appearance	Elongated, distorted, inverted or strange, unrecognisable images of distant objects.
Occurrence	When layers of air at sharply different temperature overlie a very hot or cold surface.
See also	Inversion (p.96), sunrise (p.108).

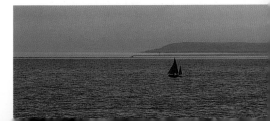

NOCTILUCENT CLOUDS

Noctilucent clouds (NLC) are beautiful, silvery-blue or white clouds seen, at midsummer, in the middle of the night towards the north (or south in the southern hemisphere). They may appear golden when low on the horizon. NLC somewhat resemble cirrus clouds and are often arranged in waves and billows.

These clouds are extremely high (about 80 km), roughly four times the altitude of even the highest normal clouds. They are visible only when the Sun is below the horizon, but still illuminates the clouds themselves. This can occur if the observing site is at a latitude of approximately 50–65° (N or S). Lower clouds are frequently seen as dark silhouettes against the bright NLC.

The clouds are very thin, and are often invisible immediately overhead, but visible to someone farther north or south who is looking along the layer. The structure is distinct from that of cirrus and five forms are recognised:

- veils featureless sheets
- bands lines of cloud, not organised
- waves herring-bone or rippled pattern (very common)
- whirls loops, swirls or twists of cloud
- complex two or more forms seen simultaneously, sometimes with bright 'knots' where waves cross

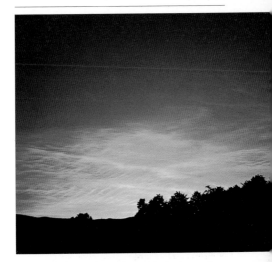

Appearance	Silvery-blue or white clouds generally resembling cirrus.
Occurrence	Visible only from 50–65° latitude (N or S) in the middle of the night. Late May to mid-August (late November to mid-February in southern hemisphere).
See also	Cirrus (p.40), aurorae (p.140).

AURORAE (Northern and Southern Lights)

Light and colour in the night-time sky may come from an aurora. Visible generally only from fairly high latitudes, it may occasionally be seen from sites much closer to the equator. The polar aurorae occur equally at northern (aurora borealis) and southern (aurora australis) latitudes. They arise when energetic particles, originating in the Sun, are accelerated by the Earth's magnetic field, and strike molecules in the upper atmosphere, which then radiate light of various, highly specific colours.

The strength of displays varies greatly. Sometimes they are pale glowing patches, easily mistaken for the glow of distant lights or dawn. At other times they weave bright curtains across the sky. Displays usually change throughout the time they remain visible. They are far above all clouds, even noctilucent clouds (p.138), at altitudes of 100–300 km. Generally, displays occur in the direction of the pole.

The major forms of aurorae are:

- glow a faint glow on the horizon
- arc a bow-shaped arch running from
 east to west; usually with a sharp base
- band a broad, ribbon-like, folded arc of
 light; often actively moving about
- rays approximately vertical streaks of
 light; often with other auroral forms
- patch a cloud-like area of light, usually seen
 late in a display; may appear to pulsate
- veil a weak, even light across a large part of
 the sky

Displays tend to begin shortly before midnight. Some may be quiet and change little, but others vary in form, extent and colour. In major displays the activity may move down to lower latitudes, and thus pass overhead. When this occurs, rays seem to converge at a point in the sky, an appearance known as a corona – quite unrelated to the phenomenon described on p.124.

The colours seen depend greatly upon your eyesight (some people are insensitive to auroral red light). The most common colour is pale green, followed by red in the upper parts of a display. Yellow, blue, violet and white are sometimes visible, but various colours are often present simultaneously. Red aurorae have frequently been mistaken for a distant town on fire.

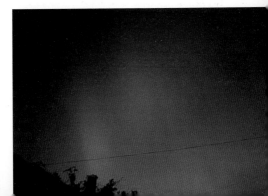

PRECIPITATION

Atmospheric water exists as vapour, liquid or solid. Any water droplets or ice crystals that are falling towards the ground are known as precipitation. Not all of this reaches the surface: some may evaporate completely. Such trails of precipitation are called virga (p.84).

Four types of precipitation are generally familiar:

- drizzle — droplets below 0.5 mm (p.240)
- rain — droplets above 0.5 mm (p.144)
- snow — clusters of ice crystals (p.146)
- hail — solid lumps of ice (p.148)

The main source clouds for these are:

- drizzle — St, Sc str op
- rain — As, Ns, Ac flo, Ac cas, Cu con, Cb
- snow — As, Ns, Sc str op, Cb
- hail — Cb

There are a number of other forms, not all of which are described here. They include:

- diamond dust — minute ice crystals that occur only under very cold conditions
- freezing rain — freezes on impact to give glaze (p.144)
- ice pellets — clear ice, below 5 mm (frozen raindrops)
- sleet — melting snowflakes, or a mixture of rain and snow
- small hail — snow pellets with thin ice coating
- snow grains — opaque, flattened ice grains below 1 mm
- snow pellets — opaque ice grains, size 2–5 mm

The amount and duration of precipitation vary greatly, from slight drizzle to torrential 'cloudbursts'. The exact nature strongly depends on the type of cloud involved. There are two very broad situations:

- Extensive stratiform clouds produce precipitation that frequently lasts for many hours. It usually begins and ends gently, and never reaches extreme rates. These conditions apply at warm fronts in depressions.

- Convective clouds produce precipitation that begins and ends suddenly, and usually lasts less than an hour. Rates vary considerably and may be extremely intense. This type of situation occurs with showers (p.212) and squall lines (p.217), and may also apply at the cold front of a depression.

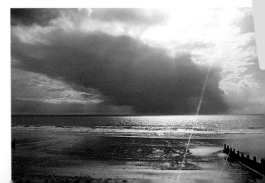

RAIN

Cloud droplets are about 5–30 μm (1 μm = 0.001 mm) across. They are so small that the slightest updraught suspends them in the air. Raindrops, in contrast, generally have diameters of 0.5–2.5 mm, although drops up to 6 mm develop under certain conditions. They may be prevented from falling only by strong updraughts.

Two processes create raindrops from cloud droplets:

- freezing ice crystals form first and clump into snowflakes, which subsequently melt into rain
- collision the largest cloud droplets sweep up smaller ones and eventually grow too large to be held in suspension

In cold clouds the droplets are supercooled, with temperatures below 0°C. This occurs because, at relatively high temperatures, solid centres (or nuclei) are required to start the freezing process. Typical nuclei are most efficient around −10°C to

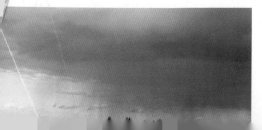

–15°C, so droplets begin to freeze in this temperature range. (If the temperature drops to around –40°C, freezing begins spontaneously.) Once freezing starts, ice crystals grow at the expense of surrounding cloud droplets. Crystals then clump together and form snowflakes, which melt when they fall into lower, warmer air.

This process is a major source of rain outside the tropics, which is why signs of freezing in cumulonimbus clouds (p.48) are significant. Ice crystals falling from higher cloud (Ci, Cs) may act as seeds and initiate freezing in lower layer clouds such as altostratus.

In warm clouds that are never below 0°C, droplets grow by collision. The process is enhanced by large initial droplets (over 20 µm), plentiful water in the clouds, deep clouds and moderate updraughts. The updraughts are important because they sweep small droplets past larger ones and increase the chances of collisions. When the weight of suspended drops becomes too high, the updraught collapses and there is a sudden shower.

All these factors occur strongly in convective clouds, especially in the trade-wind zone, 10–30° north and south of the equator, where the process predominates. It is also important in summertime clouds (i.e. cumulus congestus, p.58) in temperate regions. In winter, temperate-zone clouds are colder and contain less water. Collisions are less frequent, so the freezing process takes over.

SNOW

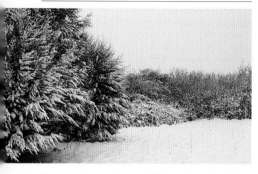

Ice crystals come in many different forms, including needles, hexagonal prisms and the beautiful plates and branching 'stellars' that are often described as 'snowflakes'. In fact, the latter consist of clumps of individual crystals that have collided, become entangled, and frozen together. This is most likely to happen when temperatures in the clouds are only just below freezing. At lower temperatures the ice crystals tend to remain separate.

A fall of snow may consist of anything from tiny ice crystals to large snowflakes, depending on conditions in the parent clouds. Low temperatures produce fine, powder snow, whereas temperatures close to 0°C give 'wet snow'. This turns to water with the slightest pressure, but refreezes immediately the pressure is removed, which can

lead to hazardous driving conditions.

The conditions for snow are similar to those that give extensive rain: the passage of warm fronts and showers (p.212). With the latter, if very cold polar or arctic air crosses open water, such as large lakes or the sea, conditions are extremely unstable, leading to the growth of large individual, organised cumulonimbus (p.48). In both cases, strong polar winds may produce blizzard conditions. The heaviest falls occur on warm fronts (in particular) and when the temperatures are close to 0°C. At lower temperatures snowfall declines.

Fresh snow contains large quantities of air, particularly falls that occur at around –15°C under calm conditions. Thawing and refreezing tends to compact any snow, so that its character gradually changes, often to more granular ('corn') snow.

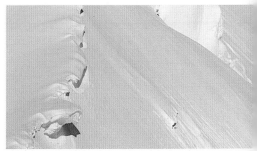

HAIL

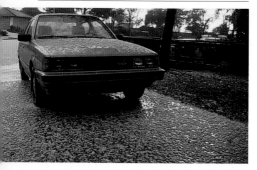

Hail consists of solid balls or lumps of ice produced inside convective clouds, which are normally cumulonimbus. Sizes range from 5 mm to 100 mm or more. (Below 5 mm, the particles are known as ice pellets.)

Hailstones vary in shape. The most common ones are spherical, but others may be conical, or simply irregular lumps of ice. The spherical type generally has internal layers, like an onion, with alternating shells of opaque rime (p.160) and clear ice (glaze). The centre may be clear (an ice pellet or frozen raindrop) or opaque (a snow pellet).

Conical hailstones (which are much rarer) usually consist of rime with a layer of glaze at the base. Irregular hailstones seem to be collections of smaller particles that have frozen together.

The layers of glaze and rime form when the growing hailstone's surroundings change. At temperatures just below freezing, there are plentiful, large, supercooled droplets. These freeze slowly and create a layer of clear glaze. At lower temperatures the droplets are smaller and fewer. They freeze instantly, trapping air between them to give opaque rime.

Such layering may indicate that a hailstone has been carried up and down inside the cloud many times, or that its surroundings have changed while it was suspended in an updraught. The updraughts sort the stones by size. Small stones may be carried far ahead of the storm, where they melt and give an early burst of rain. The largest hail normally arrives suddenly, and then gives way to medium-sized hail and rain.

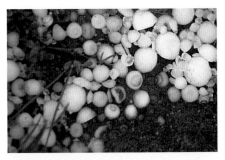

MIST AND FOG

Mist and fog occur when the temperature of the air at ground level drops to the dewpoint and condensation takes place. The difference between the two is a technical one, based on visibility:

- mist visibility 1 km or more
- fog visibility below 1 km

In weather forecasts for the general public, the description 'fog' is frequently used only when the visibility is expected to be less than 180 m.

When the temperature drops, the first water droplets to condense are small and far apart, forming mist. Later, when the droplets grow and become more numerous, the mist thickens into fog (and may happen very quickly). Similarly, when fog starts to disperse, it always thins and becomes mist before it finally disappears.

A common way for mist and fog to form is for a cold surface to cool the layer of air immediately above it. There are two basic processes by which such cooling can occur, giving two main types of fog (and mist):

- advection fog
- radiation fog

In the first, fog forms when moist, stable air is carried over a cold surface, such as the sea, or snow-covered or frozen ground. (Advection is the transport of heat by a stream of gas or air.) There must be some wind for this to happen. The same term is also used when sea fog is carried inland by a sea breeze (p.170) that builds up during the day.

On a clear night, the surface of the ground radiates heat away to space after sunset. When the

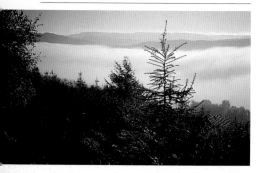

air is moist – such as after rain, or near ponds, streams or rivers – and there is a light wind, the ground then cools the lowest layer of air. Initially, dew (p.154) is deposited. If cooling continues long enough, mist forms, followed by fog. Radiation fog does not form over large bodies of water, because their temperature does not change significantly overnight.

In clean air radiation fog may form very quickly, taking no more than 10–15 minutes. It usually disperses slowly, either when sunshine warms the ground, which in turn warms the air, or if a strong wind mixes the fog with drier air.

Hill fog is simply cloud covering the hilltops. It does not imply any vertical movement of air, unlike upslope fog, which forms on the windward

side of hills when moist, stable air is forced over them. A rarer fog, known as arctic sea smoke, develops when cold air passes over a warm sea. Wreaths of 'steam' or 'smoke' rise a short distance before evaporating in the drier air above.

When air contains a large amount of smoke or certain other pollutants – as frequently happens in urban areas – fog easily forms on the innumerable tiny particles earlier than if the air were clean. Such smog (smoke fog) may become very dense and persistent, and always takes longer to disperse than a purely water-droplet fog.

Dew

Dew consists of innumerable tiny droplets of water, which are deposited on the leaves of plants (and other objects) overnight. After sunset, and particularly with clear skies, objects start to radiate heat away to space. Eventually their temperature falls below the dewpoint and water condenses from the air onto their surfaces.

The air beneath leaves acts as an insulator, so they are usually colder than the surface of the ground below. Because it is warmer, the ground generally acts as the source of water vapour, but sometimes the vapour comes from the overlying air. If the air temperature drops below 0°C, freezing occurs rapidly, to give a deposit of hoar-frost (p.158)

Some droplets on leaves may not be dew. Sometimes they are deposited from overnight mist or fog in quite substantial amounts. (In certain arid regions of the world, netting is used to trap water from fog in a similar manner.)

Plants continually extract moisture from the soil through their roots, and transport it to their leaves where it is evaporated through pores on the surface. When conditions are very humid evaporation cannot take place, so the water collects as large drops at the ends of the leaves. These are known as guttation drops and are always over 2 mm in diameter. (Ordinary dewdrops are 1 mm across, or less.) When illuminated by sunlight, tiny, individual spectra are visible within them.

There are optical effects visible in dew itself. One

is the dewbow, which is identical to a rainbow, except that its shape is not a semicircle, but an arc known as a hyperbola. It lies approximately 42° away from the shadow of your head. Some patches of dew are more effective than others, so you may have to move around to find the best position to view the dewbow.

Another effect is the heiligenschein (above). This is a diffuse white patch of light that occurs round the shadow of your head. The dewdrops and leaves act together to return light back towards its source. Technically, it is not a reflection, but is the same effect that causes animals' eyes to glow under headlights and produces 'red-eye' in flash photographs of people.

FROST

The term 'frost' is used to indicate conditions when temperatures drop below freezing, and also to describe the ice that forms on various objects.

We need to know temperatures in the layer of air just above the surface, and those on the ground. Temperatures are measured at standard heights (p.238), and forecasts use the following terms:

- air frost temperature of 0°C, 1.25 m above the ground
- ground frost temperature of 0°C, at ground level

Frost occurs either when the air and ground cool to below 0°C, or when a cold air mass arrives. With clear skies at night, the ground radiates heat away to space. The formation of mist and fog (p.150) cuts down the radiation, and may prevent temperatures from dropping to freezing.

Frost is more likely in low-lying areas that are surrounded by hills. At night, not only is heat radiated away to the sky, but cold air also slides down the slopes, displacing any warmer air. Such 'frost hollows' regularly record lower temperatures than nearby sites.

Three types of ice are also called frost:

- hoar-frost white, feathery deposits of interlocking crystals (p.158)
- rime opaque granular ice on the windward side of objects (p.160)
- glaze a transparent layer of ice

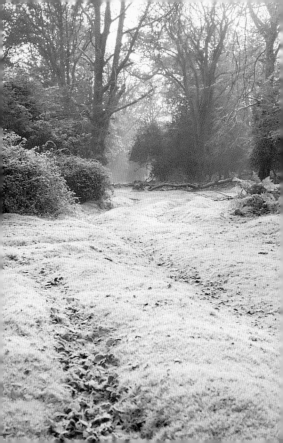

HOAR-FROST

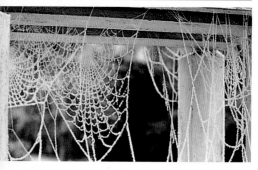

Hoar-frost (commonly just called 'frost') is a deposit of white ice crystals on objects that have cooled below freezing (usually by radiation). The deposit often consists of a mixture of dew (p.154) that has subsequently frozen and ice that has frozen directly from water vapour in the air. Small objects cool more rapidly than larger ones, so hoar-frost forms first on the edges of leaves, small twigs, wires and similar bodies.

Appearance	A fluffy deposit of ice crystals on small objects.
Occurrence	Frozen dew (p.154) or deposited directly from the air.
See also	Rime (p.160).

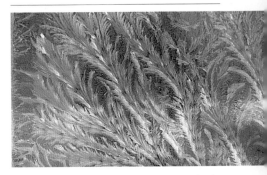

At first glance, hoar-frost and rime might be confused. Rime, however, forms on objects of any size, and is always on the windward side. Hoar-frost is the more common of the two, especially at low altitudes.

The fern-like patterns of ice crystals seen on windows grow by a method similar to one found in hoar-frost. Initially, very tiny supercooled water droplets are deposited on the glass. Once a few ice crystals have formed, these grow at the expense of the droplets, which evaporate. The vapour freezes directly onto the existing ice crystals. You can see a narrow clear space between the tips of the crystals and any remaining droplets. The thin ice on puddles often shows a similar structure.

RIME

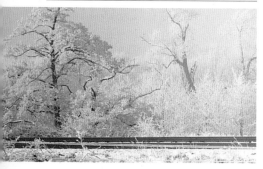

Rime is a white, opaque layer of ice that may occur on any suitable surface. It is deposited from supercooled fog, i.e. fog in which the water remains as droplets, although the temperature is below 0°C. Such conditions are often described as 'freezing fog' in weather forecasts. When the water droplets collide with something, they freeze instantaneously. The layer of ice contains numerous air pockets, which cause its white or milky appearance.

Appearance	A white, opaque layer of ice on the windward side of objects.
Occurrence	Deposited from supercooled fog.
See also	Hoar-frost (p.158).

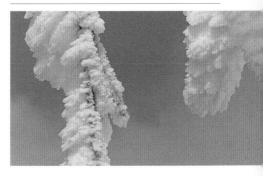

Rime consists of separate ice granules, which means that, although it is fragile, it is still harder than hoar-frost. It may be deposited under very quiet conditions, but is most spectacular when wind carries the supercooled fog past objects on the ground. The rime then builds up into long 'feathers' that point into the wind. This type of deposit is quite common on mountain tops, and the direction of the feathers indicates how the wind blows up and over the mountain.

Glaze (or 'black ice') is a clear layer of ice that forms from large water droplets that are only slightly supercooled, or which strike very cold objects and freeze instantly. It is denser and stronger than rime, and its weight may break branches and overhead wires.

WIND

Winds are always known by the direction from which they come; thus a wind blowing from the west is a westerly. Three of the factors that govern the strength and direction of the wind are:

- the pressure gradient (difference in pressure between two points)
- the Earth's rotation
- friction

These act simultaneously, but may be considered separately.

Pressure gradients generally arise from differences in temperature. When a column of air is heated it expands and becomes less dense than its surroundings. This sets up a slight pressure gradient, and cooler, denser air moves in, lifting the warm air away from the surface. A circulation (convection) is thus established.

Small pressure gradients at a specific altitude produce strong horizontal winds. (The Earth's gravity prevents the much greater pressure gradients that exist between different altitudes from creating violent vertical winds.)

Air cannot flow directly from high to low pressure regions because of the Earth's rotation, which is much faster at the equator than at the poles. Imagine a packet of air on the equator being carried eastwards by the Earth's rotation. When the air moves towards the pole (a) it retains that eastward motion, and therefore moves eastward faster than the underlying surface. It thus curves to the right in the northern hemisphere [left in the southern hemisphere]. Air moving from the poles towards the equator (b) moves slower than the underlying surface, and thus shows the same curvature to the right [left].

This Coriolis effect produces the global wind patterns. Air flowing out of the subtropical highs (p.172) towards the equator, for example, forms the trade winds, which converge from the north-east and south-east at the Intertropical Convergence Zone (p.172). On the polar side of the subtropical highs, the winds are deflected to give rise to the prevailing westerlies.

When there is a change in the wind direction, two special terms are used:

- veer wind direction swings clockwise (right)
- back wind direction swings anticlockwise (left)

The Coriolis effect thus causes winds to veer in the northern hemisphere, and back in the southern hemisphere.

A rather surprising result of the Coriolis and other forces is that freely flowing air (i.e. away from the effect of the Earth's surface) moves along the isobars, not across them from high to low pressure. The wind therefore flows round highs and lows. This freely moving wind is known technically as the geostrophic wind and occurs at heights above approximately 500 m, similar to that of ordinary cumulus and stratocumulus clouds.

At greater heights there may be other winds, driven by the different pressure distributions that occur at various altitudes in the atmosphere. At the lowest level the wind is affected by many additional factors, particularly by friction with the underlying surface.

Jet streams

Jet streams are important upper winds. They are relatively narrow bands of high-speed westerly winds, driven by the strong pressure gradients created by great temperature differences at high altitudes. They tend to follow the boundaries between warm and cold air, and thus often lie near the polar front. They lie just below the tropopause and directly influence the development and motion of low-pressure systems.

Jet streams are strongest in winter, when they tend to migrate towards the equator. Speeds in the central core may reach 400 km/h or more, but may fluctuate along their length. At times they fade away and break into separate segments. Jet-stream clouds, racing towards the east, are often easily visible from both the ground and space.

The surface wind

Friction slows the surface wind and weakens the Coriolis effect, causing the air to curve towards low

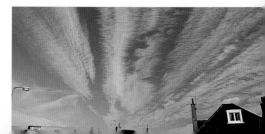

pressure. (It backs [veers] relative to the wind at low cloud level.) The amount of change depends on the surface. Over the sea:

- the wind backs [veers] by about 10–15°
- the strength is about 15% less

Over the land, the changes are more variable:

- the wind backs [veers] by 40–50°
- the strength may be 20–40% less

The approximate position of the pressure centres may be found from Buys Ballot's law. When standing with your back to the wind:

- low pressure is to your left [right] and slightly to the front
- high pressure is to your right [left] and behind you.

Wind speeds

Winds are often given on the Beaufort scale (pp.168-169), originally devised for ships at sea. In forecasts for ships or aircraft, wind speed may be quoted in knots (1 knot = 1 nautical mile per hour). Meteorologists use m/s, but km/h is easier for most people to visualise.

Wind shear

Wind shear occurs wherever adjacent streams of air move at different speeds or in different directions. In most cases two horizontal layers are involved, but shear between currents moving vertically occurs in supercell storms (p.216).

Wind chill

Even slight winds give greater cooling effects than still air on any object that must be kept at a specific temperature (such as the human body). This wind chill poses a severe hazard when low temperatures and moderate wind speeds are encountered together.

	Actual temperature °C						
	2	−1	−3	−6	−9	−12	−15
Wind Speed km/h	**Apparent temperature °C**						
0	−2	−1	−3	−6	−9	−12	−15
8	−1	−3	−6	−9	−12	−15	−18
17	−6	−9	−12	−15	−18	−23	−26
25	−9	−12	−15	−18	−23	−25	−32
33	−12	−15	−18	−23	−26	−32	−34

The BEAUFORT SCALE for use at sea

Force	Description	Sea state	Speed(knots)
0	Calm	Like a mirror	Below 1
1	Light air	Ripples, no foam	1–3
2	Light breeze	Small wavelets, smooth crests	4–6
3	Gentle breeze	Large wavelets, some crests break, a few white horses	7–10
4	Moderate breeze	Small waves, frequent white horses	11–16
5	Fresh breeze	Moderate, fairly long waves, many white horses, some spray	17–21
6	Strong breeze	Some large waves, extensive white foaming crests, some spray	22–27
7	Near gale	Sea heaping up, streaks of foam blowing in the wind	28–33
8	Gale	Fairly long & high waves. Crests breaking into spindrift, foam in prominent streaks	34–40
9	Strong gale	High waves, dense foam in wind, wave-crests topple and roll over. Spray interferes with visibility	41–47
10	Storm	Very high waves with overhanging crests. Dense blowing foam, sea appears white. Heavy tumbling sea. Poor visibility	48–55
11	Violent storm	Exceptionally high waves may hide small ships. Sea covered in long, white patches of foam. Waves blown into froth. Poor visibility	56–63
12	Hurricane	Air filled with foam and spray, visibility extremely bad	64 or more

The BEAUFORT SCALE for use on land

Force	Description	Events on land	Speed(km/h)
0	Calm	Smoke rises vertically	Below 1
1	Light air	Direction of wind shown by smoke, but not by wind-vane	1–5
2	Light breeze	Wind felt on face, leaves rustle, wind-vane turns to wind	6–11
3	Gentle breeze	Leaves and small twigs in motion, wind spreads small flags	12–19
4	Moderate breeze	Wind raises dust and loose paper, small branches move	20–29
5	Fresh breeze	Small leafy trees start to sway, wavelets with crests on inland waters	30–39
6	Strong breeze	Large branches in motion, whistling in telephone wires, difficult to use umbrellas	40–50
7	Near gale	Whole trees in motion, difficult to walk against wind	51–61
8	Gale	Twigs break from trees, difficult to walk	62–74
9	Strong gale	Slight structural damage to buildings, chimney pots and tiles, aerials removed	75–87
10	Storm	Trees uprooted, considerable damage to buildings	88–101
11	Violent storm	Widespread damage to all types of building	102–117
12	Hurricane	Widespread destruction, only specially constructed buildings survive	118 or more

LOCALISED WINDS

A number of other effects cause localised winds that affect certain areas of a country. The most important of these are:

- sea (and lake) breezes
- land breezes
- valley winds
- mountain winds

Sea (or lake) breezes occur near any large body of water. As the land is heated by sunlight during the day the warm air rises, drawing cooler air from over the water. Initially the breeze is at right angles to the shoreline, but as it strengthens it tends to veer [back]. Cumulus clouds may grow as the sea-breeze front penetrates inland, especially if there is additional lift over nearby hills. Land breezes, which occur because the land cools faster than the water at night, are similar, but generally weaker.

Night-time cooling causes valley winds. Cold air slides downhill from the upper slopes, and becomes concentrated along the axis of valleys. The same process creates frost hollows (p.156). These winds are known technically as katabatic winds, and their extreme form is found in the raging winds that roar down from ice-caps, such as those in Greenland and Antarctica.

In the daytime the upper slopes of valleys tend to heat up more rapidly than areas lower down, so warm air flows upslope as a mountain wind. This may cause cumulus clouds to appear over mountain ridges before they form elsewhere.

THE GLOBAL CIRCULATION

The atmosphere is a vast heat engine, transferring heat from the tropics towards the poles. In the tropics powerful convection continually lifts warm, moist air up into the atmosphere. A semi-permanent line of convective clouds, known as the Intertropical Convergence Zone (ITCZ), is easily visible on satellite images (pp.180–181). This rising air sets up giant convection cells north and south of the equatorial zone. Most of the moisture falls as rain over the tropics, but the air flows north and south and descends in the subtropical high-pressure zones. The descending air warms and becomes extremely dry, so this is where the world's major deserts are found.

The air flows out from the relatively stationary, subtropical highs at the surface. Some returns towards the equator, but a significant amount moves towards the poles. In the middle latitudes this warm air encounters the cold, dense air flowing from the polar regions. It is here, along what are called the polar fronts, that the warm and cold air interact to produce mobile low-pressure areas, or depressions (often called 'storms' in North America), the vast swirls of cloud and wind that dominate the weather in the temperate zones.

The exact position of the polar fronts varies greatly. They shift north and south with the changing seasons. In addition, when a tongue of cold polar air penetrates towards the equator, corresponding masses of warm air at each side push

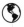

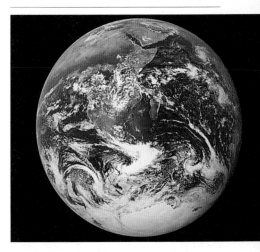

towards the pole. This constant battle between different air masses leads to complex, ever-changing weather.

The image above was obtained from an Apollo mission. It shows more of Antarctica than is visible from geostationary satellites (p.178). Note the depressions in the southern hemisphere, the Intertropical Convergence Zone near the Equator, and the cloud-free, high-pressure zone over northern Africa and Arabia.

CLIMATE

The pattern of weather (or climate) in any region is primarily determined by its geographical location, particularly by whether (or when) it is affected by maritime or continental air masses (p.176). Maritime regions (such as Western Europe, the American North-west and New Zealand) experience less variation in seasonal temperatures and have rainfall throughout the year, although they remain subject to occasional incursions of extremely cold arctic air in winter and hot subtropical air in summer.

Continental climates, on the other hand, are influenced by very cold, or very hot, air masses, which produce major seasonal variations. In the northern hemisphere winter weather is dominated by cold anticyclones over North America and Siberia. The last region, in the centre of the vast Eurasian land mass, experiences very high pressures in winter and low pressures in summer. It is these changes that drive the monsoons and draw the all-important summer monsoon rains over India and other parts of Asia.

The northern sections of the eastern coasts of North America and Asia experience cold air streams from the continental interiors in winter. Farther south, winters are milder and humid subtropical conditions prevail in summer.

Equatorial regions are not as prone to seasonal variations, although over the land there are considerable changes in the location of the

Intertropical Convergence Zone (p.172) and its accompanying rainfall. Mediterranean climates with moderate rain in winter and hot summers are additionally found in parts of California, South Africa and Australia. (The photograph below shows the Mojave Desert, California in December.)

Yearly variations also arise from fluctuations in sea-surface temperatures. Only in recent years has it become apparent how the changes known as the El Niño-Southern Oscillation (ENSO) affect sea temperatures over large parts of the Pacific, together with weather patterns over practically all of the tropics and large parts of the temperate regions.

Because of the smaller land masses in the southern hemisphere, summer/winter variations are less extreme. The dominant factor is the zone of fierce westerly winds that encircle the globe. In winter, these winds effectively isolate the Antarctic continent from the rest of the global circulation. They are a primary factor in the development of the destructive reactions that create the ozone hole in the upper stratosphere at the onset of the southern summer.

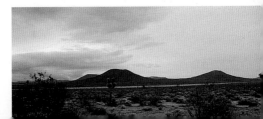

Air Masses

Air masses are large volumes of air with relatively uniform temperature and humidity. They tend to arise in anticyclones, particularly in the polar and subtropical highs (p.170), which produce polar and tropical air:

- Polar P cold or cool, unstable (heated from below)
- Tropical T warm or hot, stable (cooled from below)

Two other types are encountered:

- Arctic A extremely cold
- Equatorial E hot

These are, in effect, extreme forms of polar and tropical air.

The humidity depends on whether the air masses form over land or sea:

- continental c relatively dry
- maritime m humid

When air masses leave their source regions, their properties (particularly the humidity) alter in a way that depends on whether they pass over land or sea, and how long a path they have covered.

The most important air masses that affect temperate zones are:

- maritime Polar mP cold, humid, unstable
- continental Polar cP cold and dry
- maritime Tropical mT warm, humid, stable
- continental Tropical cT hot and dry

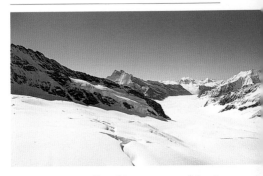

Some regions are affected by irruptions of Arctic (or Antarctic) air in winter. These are extremely cold and relatively dry (because cold air contains little water vapour), regardless of whether they originate over ice-covered land or sea. Equatorial air (mE) is always maritime, being hot and humid.

The character of an air mass is also affected by whether it is rising or falling. When it tends to subside (near a developing anticyclone), it becomes warmer, drier and more stable. When rising (near a developing depression), it becomes cooler, more humid and less stable. Although the general properties of air masses can be judged from the 'feel of the air', meteorologists use measurements made throughout the atmosphere (usually by instrumented balloons).

Satellite Images

Modern forecasting makes extensive use of measurements from meteorological satellites. For example, they are able to provide information about wind speeds and wave heights over the whole globe: details that would be quite unobtainable by other methods. As far as most people are concerned, satellite images are the most conspicuous use, because pictures are frequently included in television weather forecasts. Although instruments on the satellites obtain images at several wavelengths, the pictures shown are normally those that match the visible range, because they are the easiest for the general public to interpret.

There are two basic types of satellite and images:
- geostationary satellites full-disk images
- polar-orbiting satellites close-up images

The geostationary satellites orbit over the equator at an altitude of 36,000 km and remain effectively stationary above fixed points on the surface. Five satellites provide complete coverage of the tropics and temperate zones. A regular sequence of images of the Earth's disc is returned throughout the day and night. These images (or sections of them) are often combined to give the time-lapse sequences of the movements of clouds and weather systems that are shown in television forecasts. Geostationary satellite images are shown on pp.180–183.

Polar-orbiting satellites orbit at lower altitudes

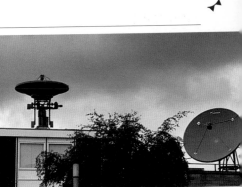

(around 1,000 km) and normally cross the equator 15 times a day. For a particular point on the surface, the orbits usually carry them overhead twice a day (at approximately noon and midnight local time). Their images are far more detailed, but do not provide such close coverage of specific weather systems. Polar satellite images are shown on pp.184–189.

Images from both types of satellite are obtained not only by various meteorological services, but also by a large, and increasing, number of amateurs. Signals from geostationary satellites are picked up by fixed, dish aerials (right, above). For the polar-orbiters the aerials (left) need to track the satellites as they pass within range of the ground station.

SATELLITE IMAGES – 24 February

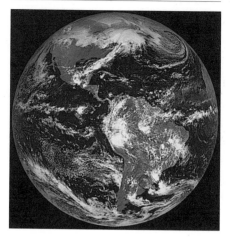

The line of convective clouds marking the Intertropical Convergence Zone (p.172) is readily visible over the Atlantic Ocean, but less distinct over the Pacific. Well-defined depressions lie over the North and South Atlantic. Both show bent-back occluded fronts (p.184) and, behind the cold

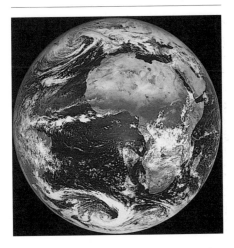

fronts, speckled lines and clusters of showers that have formed over the relatively warm seas. In contrast, the depression that is lying over the east coast of North America has a large area of cold, cloud-free air behind its cold front. (Meteosat images, 24 February.)

SATELLITE IMAGES – 30 August

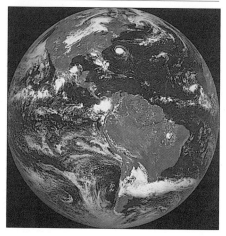

In these images, taken during the northern hemisphere's summer, the clusters of thunderstorms over equatorial Africa are particularly noticeable, as are other clusters in the western hemisphere. Both images were taken at approximately noon local time, but the left-hand

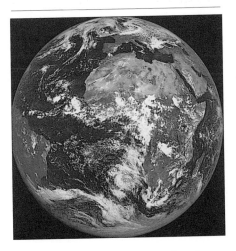

image was obtained five hours later than that on the right. Changes in the convective clouds over the Atlantic off West Africa are obvious. In the western North Atlantic the tight swirl of clouds of Hurricane Emily is very conspicuous. (Meteosat images, 30 August.)

WEATHER MAPS

On weather maps, lines called isobars join points of equal pressure. Winds (p.162) blow approximately along the isobars, flowing slightly in towards the centres of lows (depressions or cyclones) and out from high-pressure areas (anticyclones). The closer the isobars, the stronger the winds.

Warm and cold fronts, the boundaries between air masses of different temperatures and humidities, are shown by specific symbols, which indicate the front's direction of advance. An occluded front shows where the warm air has been lifted away from the surface.

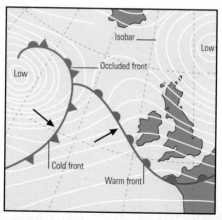

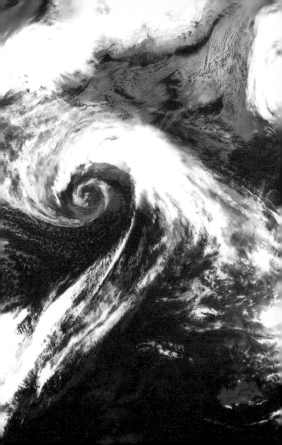

A Depression or Low

A broad belt of cloud precedes a depression's warm front and a narrower one marks the advancing cold front. The warm sector lies between them. An occluded front runs close to the low-pressure centre, marked by a swirl of cloud.

Behind the cold front, speckled clouds are showers, some organised in clusters, swept along by the polar air. A bulge in the cold front marks the position of a wave, which may signal the beginning of a new, secondary depression.

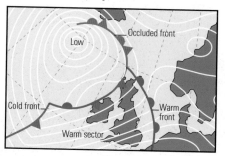

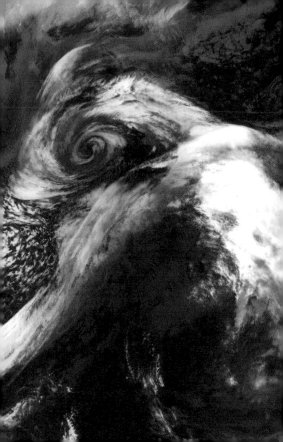

RIDGES AND TROUGHS

Low-pressure areas extend their influence as troughs. A line drawn through the sharpest points on the various isobars defines the axis of a trough. Similarly, anticyclones extend in the form of ridges of high pressure, often marked by clear, or clearing, skies.

When pairs of high- and low-pressure areas form a symmetrical pattern, an area of slack winds lies between them. This region, where two ridges and two troughs meet, is known as a col, here crossed by the remnants of a weak occluded front.

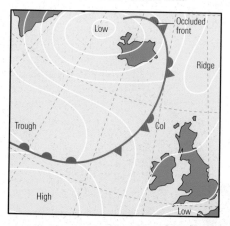

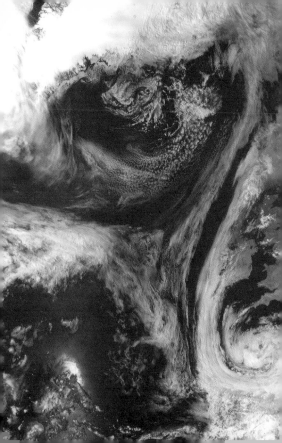

An Anticyclone or High

An almost stationary high-pressure area, or anticyclone, over central Europe is largely cloud-free. Anticyclones act as obstructions to the movement of depressions. This anticyclone has forced a depression, with its fronts and accompanying clouds and rain, to swing north over Scandinavia.

A wave is visible on the long, trailing cold front, where a new depression could develop. Behind the cold front a ridge of high pressure has produced a belt of relatively cloud-free air ahead of the next depression farther west.

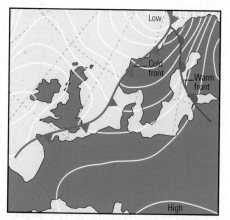

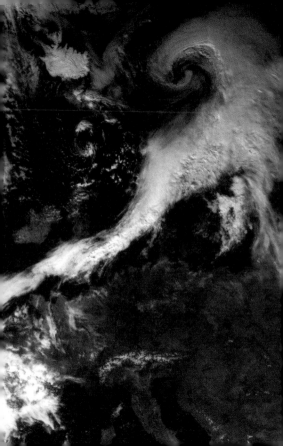

CONVECTIVE CLOUDS

Large cumulonimbus clouds often become organised into lines and clusters. Sometimes this takes the form of a squall line, or isolated cold front. Sometimes they form near small, active, low-pressure areas (right) and mimic the appearance of normal fronts.

The right-hand low-pressure area has formed on a front trailing behind a main depression off the image to the bottom right. There are other large cumulonimbus clouds toward the bottom of the image, particularly below the left-hand low.

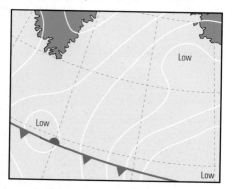

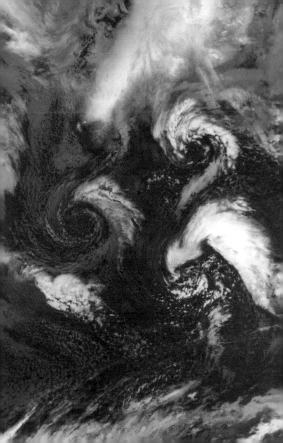

WEATHER SITUATIONS

Weather forecasts become easier to interpret if you have some knowledge of various weather situations and how they are likely to develop. Every situation is different, so there are many variations that may occur. In particular, the speed of change (such as the advance of fronts or the onset of rain) is often extremely difficult to predict. This is where local knowledge, and the ability to read the sky and clouds, becomes important.

The most important situation, because it covers such a wide range of features and types of weather and is so variable in its effects and severity, is the depression. The sequence as the warm and cold fronts and the intervening warm sector pass over an observer is described in some detail (pp.198–207). Changes at other points, and the weather associated with other fronts, lows and troughs, are also covered briefly (p.208).

Anticyclonic weather (p.210) tends to be quieter than that accompanying depressions, and usually changes more slowly. Over continental areas in particular, high-pressure areas may dominate the weather for long periods. Finally, showers (p.212) and thunderstorm activity (p.214) are very typical of certain weather situations.

The most significant variations not discussed concern the way in which local conditions (particularly hills and mountains, and large bodies of water) modify the behaviour of depressions and affect showery conditions.

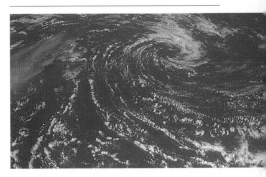

It is important to have a clear idea of the direction of surface winds around high- and low-pressure centres. In the northern hemisphere these are:

- high (anticyclone) clockwise
- low (cyclone) anticlockwise

In the southern hemisphere:

- high (anticyclone) anticlockwise
- low (cyclone) clockwise (above)

These descriptions apply to winds at the surface, not at higher levels. Satellite images are occasionally deceptive: there is often an outflow of air at high altitudes above depressions and hurricanes. The high-level cirrus may show distinct indications of anticyclonic curvature. In the case of hurricanes, the cirrus shield may mask the underlying circulation almost completely (p.231).

DEPRESSIONS

In middle latitudes, major changes of weather occur with the passage of depressions, or low-pressure areas. Although every depression is different, they all have a similar structure and there is a well-established sequence of events and features that most have in common.

Depressions begin as a small wave on a polar front, the boundary between warm air moving away from the subtropical high-pressure regions (p.172) and cold air flowing from the poles. This wave increases in size until distinct warm and cold fronts (pp.198 and 206) develop, together with a closed circulation of winds blowing round a low-pressure centre. Along the warm front, on the eastern side, warm air is sliding up over a shallow wedge of cooler air. The slope of the frontal zone is very gentle: between approximately 1 in 100 and 1 in 150.

The cold front, on the western side, is where the cold air is undercutting the warm and lifting it away from the surface. This front has a steeper slope: about 1 in 50 to 1 in 75. Between the two fronts is the region known as the warm sector.

Air is forced to rise at both fronts, producing extensive clouds, which are stratiform (p.18) on the warm front and either stratiform or convective (p.192) on the cold front. Cloud formation releases latent heat, which provides the energy that drives the winds in the depression and may cause it to deepen and become more intense.

Jet-stream clouds, like those shown on p.8, may

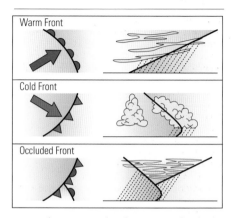

give early warning of a depression. Ahead of a depression the path of the jet stream is usually from west to east, or north-west to south-east [SW to NE]. If the lower wind is 'crossed', blowing at roughly right angles to the upper wind – and thus from an approximately southerly [N] direction – a depression is on its way. Because the circulation around a low is anticlockwise [clockwise] (p.195), this implies that the centre is away to the west.

If the winds were crossed, but the lower one was blowing from the north or north-west [S or SW], the observing site is behind the cold front, and the depression is just passing away to the east.

WARM FRONT APPROACHING

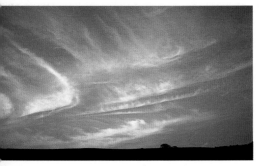

There is a set of characteristics observed as a warm front approaches. Naturally, there are variations from depression to depression, particularly in the amount of cloud cover. There may also be certain differences in the direction of the wind.

The signs of an approaching warm front:

- wind increases and backs into the south [veers to N]; crossed winds
- pressure drops at an increasing rate
- cloud cover changes in a well-established sequence: Ci, Cs, As, Ns, St
- precipitation increases and becomes more continuous
- visibility good, then deteriorates
- temperature decreases
- dewpoint steady

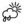

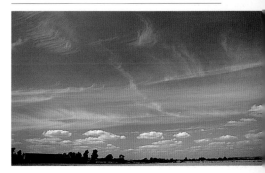

Most of these are self-explanatory. The dewpoint (p.94) indicates the humidity of air at the surface.

Even if there is no jet-stream cirrus, ordinary cirrus appears ahead of the front, where warm, moist air has been carried to great heights. Cirrus forms at altitudes of about 6 km, so with a slope of 1 in 100–150, the front can be roughly estimated to be about 600–900 km away.

The cirrus increases, covering more and more of the sky. Heating by the Sun gradually decreases and warmer air is moving in aloft, so stability increases. If convection is present, it starts to die away and the cumulus become cumulus humilis (p.56). If the air ahead of the front is stable – maritime (p.176) rather than polar air, for example – any stratiform clouds tend to persist.

The cirrus continues to increase and gradually spreads into a sheet of cirrostratus. Initially, this may be just a thin veil, hardly detectable to the eye. This is the time when you are most likely to see haloes (p.128), mock suns (p.130) and circumzenithal arcs (p.132), and rarer halo phenomena.

Generally, this stage lasts for a very short period, until the cirrostratus becomes too thick for the optical effects to be visible. By now, the cirrostratus is easier to see and usually shows a more distinct fibrous structure. Although the Sun is still very bright, a slight drop in temperature is generally apparent. This feeling is reinforced by the fact that the wind usually strengthens.

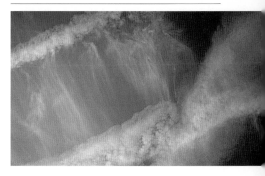

Because the air carried up ahead of the warm front is moist, in comparison with the cooler air to the east of the depression, it affects aircraft condensation trails (p.91). Normally these evaporate into the surrounding, drier air. Now, however, they do not break up rapidly, but instead linger long enough for the water vapour to freeze. The resulting ice crystals are very persistent and can, under the right conditions, last for hours.

Because the crystals persist, upper-level winds have time to spread out the contrails into broad bands of 'cirrus' cloud. Eventually these may form a significant part of the cloud cover. So these are more signs that a warm front is approaching: look for halo phenomena and persistent contrails.

AHEAD OF WARM FRONT

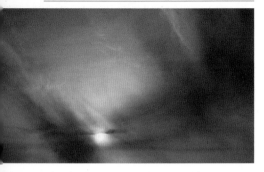

The cloud continues to thicken and lower. Now it has become a sheet of altostratus (p.36), which often shows a fibrous structure parallel to the upper winds. The cloud may contain either water droplets or ice particles in the form of snowflakes. The Sun's disk is still visible, but is diffused as if seen through ground glass. Generally, any precipitation evaporates before it reaches the ground, but sometimes there may be a little rain or snow.

Eventually the altostratus becomes so dense and low that precipitation does reach the ground. The cloud is now nimbostratus. The rain or snow is usually more or less continuous, although there are often bands of heavier precipitation that run approximately parallel to the front. The frontal zone is nearly overhead.

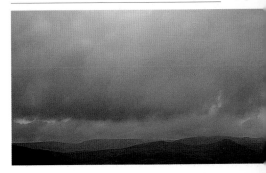

On charts a warm front appears as a sharp boundary between the different air masses. In fact, it is a frontal zone where there is some mixing of the two types of air. At the surface it may be about 100 km wide, so it takes some time to pass over an observer. As it does so, there are distinct changes in the prevailing conditions:

- wind veers, from SE or S to SW [backs from NE or N to NW]
- pressure steadies (ceases to fall)
- cloud cover usually Ns
- precipitation ceases or may decline to drizzle
- visibility deteriorates
- temperature cool in downdraughts caused by rain
- dewpoint rises with arrival of warm air

THE WARM SECTOR

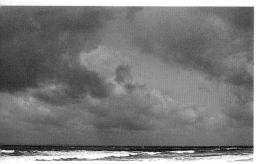

The warm sector has arrived:

- wind direction and strength are steady
- pressure steady, unless depression is deepening
- cloud cover variable (see below)
- precipitation occasional light rain or drizzle
- visibility moderate to poor, fog likely over sea
- temperature rises
- dewpoint steady

Cloud amounts depend on the distance from the centre. Nearby, the cloud may be unbroken stratus or stratocumulus up to the cold front and precipitation may persist. Farther away the cloud is likely to be broken. If the warm air is unstable cumulus may develop, which with higher remnants of frontal cloud may give rise to mixed skies.

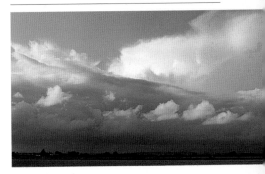

Conditions remain steady in the warm sector until the cold front is close:

- wind may back [veer] slightly and increase near front
- pressure falls close to front
- cloud cover St, Sc, thickening to Ns (in stable air)
- precipitation heavy near front
- visibility moderate or poor, fog likely over sea
- temperature little change
- dewpoint little change

When the warm air is stable, stratiform cloud often obscures the approaching cold front. The cloud sequence may be the reverse of that at a warm front, but cold fronts are frequently more vigorous, and take the form of a line of cumulonimbus. (A squall line may be regarded as an isolated cold front.)

COLD FRONT

There is a dramatic change as the cold front passes:

- wind suddenly veers [backs], possibly with severe squalls
- pressure sudden rise
- cloud cover changes to Cb, associated types and species
- precipitation heavy rain, possibly with hail and thunder
- visibility poor in rain showers
- temperature abrupt drop
- dewpoint sudden fall with arrival of cold air

Because cold fronts slope more steeply than warm fronts, the rain-belt is generally much narrower. There may, however, be bands of rain in the warm sector, approximately parallel to the cold front itself.

In the clear air behind the front, the rear of the front, with its trailing high-level cirrus, may appear very dramatic, especially when lit by the setting Sun.

As the cold front passes away to the east, and polar air moves in, certain final changes occur:

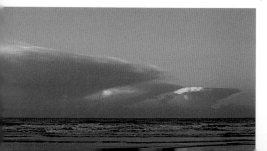

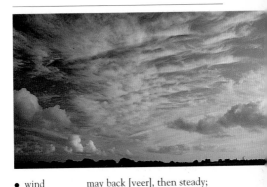

- wind may back [veer], then steady; becomes gusty and stronger
- pressure rate of rise gradually decreases
- cloud cover often clear immediately behind front, then Cu and Cb develop
- precipitation often fine for 1–2 hrs, then showers
- visibility very good
- temperature steadies
- dewpoint little change

The conditions behind the cold front usually give rise to extensive convective clouds, which may grow into substantial showers (p.212).

Note that some weak depressions are very subdued, with just thick stratocumulus on both warm and cold fronts. The other changes are still apparent, however, even if not so marked.

OTHER FRONTS AND LOWS

The sequence described assumes that the low's centre lies between the observer and the pole. If it follows a path to the south [north] there are no distinct fronts, but, depending on the observer's exact position, there will be increasing cloud cover and possibly a fairly prolonged period of rain. The cloud sequence will be similar, but total amounts of precipitation will normally be less, and the convective activity, clouds and squalls associated with the cold front are absent. The wind will tend to back continuously from east right round to north or even north-west [veer from east to south or south-west].

Close to the centre a slightly different type of front may be encountered. A cold front generally moves faster than the warm front, which it overtakes from the west. When it does so, it gradually lifts the air in the warm sector away from the ground. Beneath the pool of warm air the two fronts merge into what is known as an occluded front. There may still be a broad band of precipitation, which persists until the depression begins to decay.

An occluded front is preceded by a cloud sequence similar to that at a warm front, but it tends to have more low-level cloud, especially in the warmer of the two 'cold' air masses. Although the wind still veers [backs] as the front passes, it is usually immediately obvious that one cool air mass has been replaced by another.

Waves may develop on the cold front close to the

208

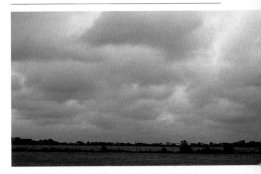

parent low, which may turn into true secondary depressions. These can bring prolonged cloudy, wet conditions, when otherwise clearance behind the cold front might be expected.

Certain lows are not associated with fronts. Strong heating during the daytime, particularly over continental areas in summer, may create thermal lows. In polar air, these increase the instability and may produce showers or thunderstorms. They decay when heating is cut off at sunset. Similar features known as polar lows and – slightly less active – polar troughs, occur when polar air is drawn across relatively warm seas behind a large, occluded depression. Such lows may become very active, because warming occurs even at night.

ANTICYCLONIC WEATHER

Anticyclones (high-pressure areas) are typically slow-moving and accompanied by stable conditions (p.98) and slow changes in the weather. There are two types:

- cold anticyclone — cold, dense air occurs close to the surface, below about 3 km
- warm anticyclone — air near the surface and in the middle troposphere is frequently warmer than normal; cold air is found in the upper troposphere and lower stratosphere

Cold anticyclones are typical of winter conditions. Cold dense air builds up over the polar regions. Skies are often cloudless, and temperatures extremely low. Outside the polar regions, cold anticyclonic conditions are usually in the form of a ridge, rather than a true high-pressure centre. An inversion often develops at a relatively low altitude. This restricts the growth of cumulus, which tend to spread into thick stratocumulus. When skies are clear, temperatures drop rapidly at night.

The subtropical high-pressure regions are typical warm anticyclones. Air is subsiding, and warming, throughout the depth of the troposphere. This tends to suppress cloud formation, but some broken cumulus or stratocumulus may occur.

When the surface air is warm and moist (tropical maritime air, p.177), extensive stratus or fog may occur. In winter this tends to be very persistent,

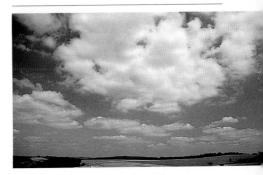

especially because winds are light. In summer, daytime heating is often sufficient to disperse the cloud.

The thick stratus or stratocumulus clouds that occur in anticyclones produce heavy, overcast skies that frequently persist for days (or even weeks). Such conditions are known as 'anticyclonic gloom'.

In a warm high, air is subsiding throughout a considerable depth of the troposphere. This acts as a barrier to the normal flow of westerly winds. The polar front and depression tracks lie farther north or south than usual. Such 'blocking highs' tend to occur in specific locations, and may bring weather in sharp contrast to the normal for the time of year. Weather over surrounding areas is influenced in the same way, with persistent winds from one direction and little change in temperature or humidity.

Showers

The word 'showers' is often taken to mean intermittent rain, but to meteorologists and in most weather forecasts it specifically indicates precipitation from cumulus or cumulonimbus clouds. The spasmodic periods of rain that vary in duration and intensity during the passage of a frontal system are normally described as bands of rain, although showers may sometimes be embedded in the more general rain at a cold front.

Showers are an indication of unstable conditions (p.98), such as when there is strong heating of the ground during the day, which produces vigorous thermals that develop into cumulus congestus (p.58) or cumulonimbus (p.48). Showers over the land are particularly intense during summer, when heating of the ground is greatest. Similarly, favourable conditions often occur behind a cold front, when cold, relatively dry air may be drawn across a warm, moist surface. This is particularly true when the cold air flows across warm seas.

The intense rain that often occurs with showers arises because the updraughts within the cloud have a limited lifetime. While they are strong they are able to support large raindrops against the force of gravity, but when they decay the rain is released as a sudden downpour. When the convection is particularly vigorous, such as in large cumulonimbus clouds, the updraughts are capable of supporting ice pellets or hailstones (p.148) and may turn into thunderstorms (p.214).

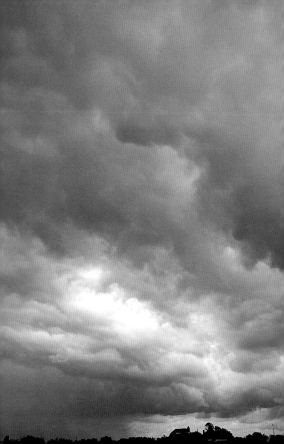

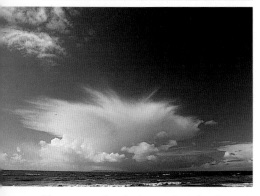

The strong updraught in cumulonimbus draws air into the cloud, particularly from the region ahead of the storm. Anyone on the ground often feels a gentle wind blowing towards the cloud. This is one reason why people sometimes say that a thunderstorm approached 'against the wind'. In fact, ordinary thunderstorms are carried along by the prevailing wind at low-cloud level.

The inflow brings fresh, heated air from the ground into the bottom of the storm. This helps to sustain the main updraughts within the cloud. These updraughts carry tiny, positively charged droplets to the top of the cloud, and thus provide the mechanism that gives rise to lightning (p.218).

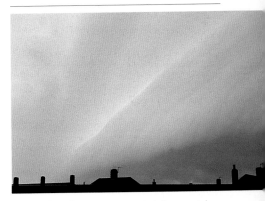

The updraught is accompanied by a violent downdraught of cold air. When this hits the ground it fans out in all directions. The wind at the ground comes in gusts, which are sometimes very strong and blow away from the cloud. The cold air tends to lift the inflowing air away from the surface some distance away from the storm along a squall front. As the air is lifted, wisps of cloud appear as condensation occurs. Sometimes, the strong wind shear and uplift produce a sharply defined shelf of cloud where the air is flowing up into the storm. In some cases, two or even three distinct layers may be seen. Occasionally, there is a distinct, separate roll of cloud (known as arcus) in front of the storm.

SEVERE STORMS

The uplift at a squall front often triggers instability, so there is a tendency for new convective cells to form ahead of the main storm – usually slightly to the right of the direction of the storm's advance (in the northern hemisphere). Sometimes there is a whole line, known as a flanking line, of cells, which increase in size towards the storm centre. Such cells develop and merge with the older cells as the storm moves across country.

Severe storms establish a large-scale, organised airflow in which cold air is constantly undercutting a warm inflow. The intense core in such a storm may shift towards the right forward flank, or in extreme cases, even move upwind. The large-scale airflow causes intense vertical wind shear, which intensifies and prolongs the storm.

In multicell storms many cells are active at once. Usually these cells extend in a line, similar to the flanking line seen in smaller thunderstorms. As old cells die away new ones replace them. Such storms may persist for hours and often progress across country in a series of surges, usually moving slightly to the right of the main wind flow. Hailstorms are frequently of this type.

Even more extreme are the supercell storms. Here, rather than having multiple cells, the whole system develops into a single, giant, organised circulation. An extremely violent main updraught produces a large dome above the principal anvil. Such storms persist for many hours.

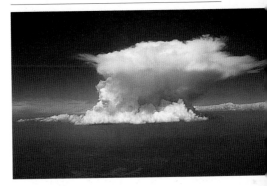

A squall line may be likened to a larger, more vigorous version of a squall front. It often forms when a multicell or supercell storm decays and sends a surge of cold air across country. This undercuts warm air along an extended line and produces a long, active core, rather than particularly strong, large, individual cells. The linear nature is preserved even though small, intense cells migrate backwards from the active front.

Such squall lines are similar to active cold fronts (p.206). They are often immediately preceded by a long, shelf cloud or turbulent roll cloud, where air is rising sharply into the bottom of the storm. There is usually a sudden wind shift as the gust front reaches the observer.

LIGHTNING

Lightning (with its accompanying thunder) occurs mainly in tall cumulonimbus clouds, although some arises in very unstable middle-level clouds, warning of which may often be seen in altocumulus floccus (p.66) and altocumulus castellatus (p.67). The violent updraughts that are found in such clouds (and which may produce hail under certain conditions) act to separate positive and negative charges within an individual cloud. Generally, positive charge accumulates at the top and negative charge at the bottom. Normally, however, there are pockets of different charges at various levels in the cloud. The cloud itself induces opposite charges on the ground, so there is normally a positive charge immediately beneath the cloud. This charge follows the cloud as it is carried over the surface by the wind.

Lightning is a giant discharge (a spark) between regions of different charge. This occurs when the charges become so great that they overcome the electrical resistance of the intervening air. Discharges may be between different parts of the cloud, or between the cloud and the ground. Although the distinction is a little artificial, two names are commonly used:

- sheet lightning cloud to cloud strokes
- fork lightning cloud to ground strokes

There is really no difference between the two, but with sheet lightning part or all of the actual channel is hidden by cloud, which therefore seems to be lit from within. Fork lightning looks like the straggling

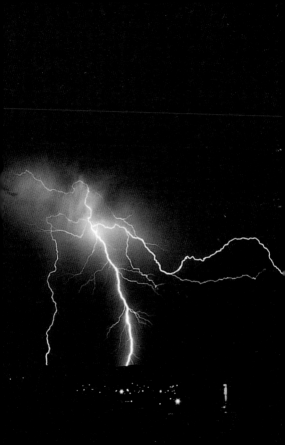

roots of a tree reaching down from the cloud to the ground.

A single flash actually consists of several discharges occurring within split seconds of one another, which is why lightning often seems to flicker. On very rare occasions it is just possible to see the separate strokes from a rapidly moving train or aircraft, because the motion spreads the image across the retina of the eye.

At night, provided the intervening sky is clear, lightning flashes may be seen at amazing distances: even more than 150 km. The sound of thunder, by contrast, although often heard 15 km away, is rarely detectable beyond 30 km. Because light from flashes travels almost instantaneously (at 300,000 km/s) and sound moves far slower (about 330 m/s), counting the seconds between a flash and the rumble of thunder provides an easy way of determining the distance. A three-second interval is approximately equal to 1 km.

The sound produced by lightning tells you something about the stroke. A short, sharp crack indicates that the lightning channel itself is short, whereas a prolonged rumble shows that some of the sound has taken much longer to reach you, and therefore originated much farther away.

Thunderstorms frequently consist of a number of active cells, each of which may last for 30–60 minutes. When several cells are active (in a multicell storm) it is often possible to detect the different cells from the positions and distances of the flashes. Over time old cells become inactive and new ones arise.

Various other forms of atmospheric electricity are sometimes encountered. Lightning often occurs during volcanic eruptions, for example, with a distinctive, sharp, crackling sound. Some other forms are:

- St Elmo's fire a continuous glowing discharge, from sharp objects on the Earth's surface such as masts, church spires, trees, and even hair or fingers

- ball lightning a very rare (and often disputed) glowing, spherical region of air, a few centimetres across, which may drift around with the wind, and vanish suddenly (with or without a noise)

- rocket lightning rare lightning that extends upwards from the top of clouds, apparently ending in the clear air above

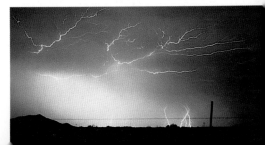

THUNDERSTORM SAFETY

Lightning is potentially very dangerous, so it is important to know how to avoid being injured. Lightning generally strikes the highest object in the vicinity and is also attracted to sharp objects and good conductors, such as any form of metal, and water. You are relatively safe:

- inside a building (especially one with a steel frame or proper lightning conductor)
- inside a car with a metal body
- in a valley
- in very thick trees (and preferably sheltering beneath the shorter ones)
- in a ditch or depression (but out of any water)
- as a last resort, crouching down in a low place

You should avoid:

- high places (hilltops or mountain ridges)
- isolated trees, telephone poles, etc.
- wire fences
- wet ditches
- anywhere in or on water
- standing up (especially sheltering under an umbrella or swinging a golf club)
- lying flat on the ground

Lying flat is not safer than crouching down, because it is important to cover as small an area as possible. This minimises the chances of the current passing through the centre of your body and affecting your heart. When crouching, lightning tends to pass over the surface of your body on its way to ground, and frequently produces nothing worse than fern-like

Tuck head
onto knees

Crouch on balls of
feet to minimise
area in contact
with ground

patterns on the skin that fade within a few hours.

If caught by a thunderstorm when sailing, wrap a length of anchor chain round the shrouds and trail it over the side into the water. This will conduct any stroke that hits the mast straight to ground. You will be safer than if you were in a rowing boat without a mast. (It is sensible, however, to avoid handling the halyards if possible.)

Inside a house:

- disconnect electrical appliances, television sets and computers
- stay away from windows, doors and chimneys
- do not use the telephone
- stay away from plumbing; do not take a bath or shower

TORNADOES

The worst tornadoes are produced by the largest and most violent thunderstorms, the so-called supercell storms. In these, unlike the numerous individual cells found in multicell storms (p.216), the circulation within the cloud becomes organised into a single, powerful updraught and two areas of downdraught on the forward and rear flanks. It is in the region of intense wind shear between the updraught and the rear flank downdraught that tornadoes develop.

The first sign of a tornado is often what is called a 'lowering', a mass of cloud below the main cloud base. This may be difficult to see, because that area of the storm is frequently obscured by heavy rain and hail. The cloud that forms the lowering (the wall cloud) normally shows obvious rotation and vertical motion as air is drawn up into the main cloud base. A funnel grows down from the centre of the wall cloud and then makes contact with the ground.

The trunk is normally visible because water vapour condenses within it, although sometimes tornadoes are first recognised by the cloud of debris that they raise from the ground. There may be descending air in the very centre, and sometimes the cloud is thin enough for the trunk to appear as a hollow column. Secondary vortices that revolve around the main trunk occasionally occur. Most tornadoes rotate anticlockwise, but the opposite direction is also encountered.

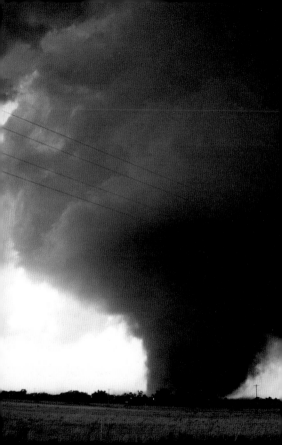

The diameter of tornadoes at the surface may be 100–500 m. Generally, the most destructive tornadoes have the widest trunks. Wind speeds are very high, typically 150–300 km/h. The duration may be just a few minutes to an hour or more.

Depending on the parent storm's movements, the tornado may be stationary, or leave a trail of devastation many kilometres long. Some break away from the ground for a while and then touch down again.

Because tornadoes are so dangerous, it is important to understand the meaning of the terms used to warn the public. Detailed information is available in the USA and Canada, where most devastating tornadoes occur.

- Tornado watch Conditions are suitable for the formation of tornadoes. Begin to take precautions. Be alert for signs of a tornado. Ensure that you hear any specific warnings that are issued.

- Tornado warning A tornado is extremely likely or has been sighted on the ground. Danger is imminent. Take cover in a tornado shelter or basement. Leave your vehicle – even a ditch is better protection than a car.

As the violent air movements within the storm begin to weaken, tornadoes usually become thinner

and longer and assume a rope-like appearance, trailing behind the cloud. They often lift away from the surface and gradually retreat upwards into the cloud base. Note that not all tornadoes are accompanied by thunder, so this cannot be taken as a warning sign.

Waterspouts are similar to tornadoes, but they seem to be less powerful, probably because the temperature differences over water are less. Other similar, but less destructive, funnel clouds (tuba) occur quite frequently. They form, for example, on gust fronts, in cold, humid air under rapidly growing convective clouds, or beneath cumulonimbus clouds and multicell storms. Although the funnel is normally visible, some of these miniature tornadoes, especially those on gust fronts, are invisible, and detectable only by the plume of debris and the damage that they leave behind. Many funnels never reach the ground.

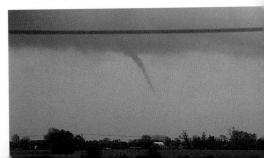

WHIRLS AND DEVILS

Small whirlwinds or devils, unlike more destructive tornadoes and waterspouts (pp.224–227), are not created as a result of the violent up- and downdraughts in cumulonimbus clouds. Instead they are a rotating column of air that starts at the surface and extends upwards. The column is visible because of the material (dust, sand, snow, straw or water) that it lifts from the surface.

Whirls arise when there are sharp horizontal differences in wind speed. Such wind shear often occurs when an area of ground is rougher than another, or when landscape features tend to funnel the wind through a narrow gap – the usual cause of snow and water devils.

Localised heating of the surface may accentuate the rotation. Some of the sand and dust devils that are common in hot countries may reach heights of a few hundred metres. When conditions are suitable, whole families of devils may occur simultaneously. Once established, a whirl may persist, and follow a curved track across the ground. Eventually the source of energy becomes exhausted, the base rises from the surface, and the rotating column of air collapses.

Appearance	A rotating column of air, carrying loose material up into the sky.
Occurrence	Wherever local conditions promote strong horizontal wind shear.
See also	Wind shear, tornadoes (p.224).

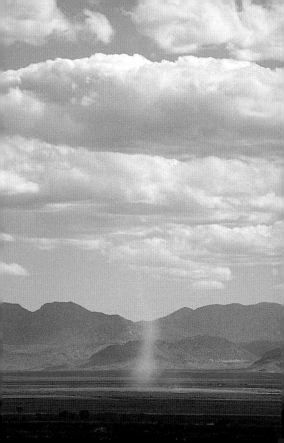

HURRICANES

Hurricanes are one of a family of destructive storms that occur over the tropics and low temperate latitudes. The term used to describe these systems depends on where they occur:

- hurricane North Atlantic, Eastern Pacific
- typhoon Western Pacific
- cyclone Indian Ocean, Coral Sea
- tropical cyclone Worldwide (the meteorological term)

(Depressions, which have some similarities, are known to meteorologists as extratropical cyclones.)

Hurricanes originate over the oceans north and south of the equator, generally in the region between latitudes 7° and 15°. They begin as clusters of powerful thunderstorms like those that occur regularly along the Intertropical Convergence Zone (p.170). These draw their energy from the heated ocean surface. If other factors – such as conditions in the upper atmosphere – are favourable, a closed circulation becomes established around a low-pressure centre. The systems intensify and central pressures drop as the storms move away from the equator. Pressures of less than 900 mb have frequently been recorded.

The exact term used for the developing systems depends on their sustained wind speeds at the surface:

- tropical depressions below 60 km/h
- tropical storms 60–118 km/h
- hurricanes above 118 km/h

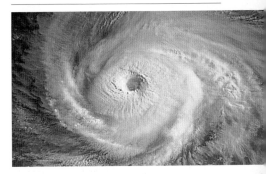

For ease of identification, and particularly to avoid confusion by the general public, the systems are given names at the tropical storm stage.

Vast walls of towering cumulus clouds spiral around the centre and pump enormous quantities of moisture into the atmosphere. The bands of convective clouds and the clearer belts between them are hidden from above by a vast shield of cirrus that spreads out above the storm. The centre, or 'eye', where air is descending, is cloudless, and is typically 20 km across. It may be less, however, especially when winds are particularly strong.

The highest wind speeds occur in a belt 25–40 km wide around the eye. Sustained speeds of 240 km/h, with gusts to as much as 360 km/h, may occasionally occur in the strongest storms. Within

the eye winds may be no more than 25 km/h, which seems calm by comparison.

The normal lifetime of a hurricane is about 9–10 days. They generally move westwards, with an overall speed of about 20 km/h, gradually curving away from the equator to higher latitudes. Both the speed and direction may be erratic. Because the paths are somewhat unpredictable, it is important to understand warning forecasts:

- Hurricane watch: An existing hurricane could affect your area. Review emergency arrangements, including evacuation routes. Ensure you hear any further warnings.

- Hurricane warning: A hurricane is imminent. Complete emergency arrangements. Move from low-lying areas and mobile homes. Evacuate area completely if advised to do so.

The words used to describe the time until a hurricane's arrival have specific meanings:

- imminent within 6 hours
- soon in 6–12 hours
- later more than 12 hours away

The destructive power of hurricanes comes from three factors:

- high wind speeds
- torrential rain and subsequent flooding
- storm surges

Storm surges often cause most damage and are the

least expected. The low pressure raises the sea surface much higher than normal. Away from land this may be about 0.5 m high, but on the coast it may be 5 m or more, even ignoring the effects of the tide. A vast wall of water may be driven many kilometres inland by ferocious winds, and can cause utter devastation over a wide area.

The severity of hurricanes is assessed on the Saffir–Simpson scale:

Category	Pressure (mb)	Wind Speed (km/h)	Storm Surge (m)	Damage Potential
1	above 980	118–154	1–1.5	minimal
2	980–965	155–178	1.8–2.4	moderate
3	965–945	179–210	2.7–3.7	extensive
4	945–921	211–250	4.0–5.5	extreme
5	below 921	over 250	over 5.5	catastrophic

When hurricanes move over land they lose their source of energy and soon weaken. All systems eventually turn east, and their remnants may combine with a wave on the polar front to produce a particularly vigorous mid-latitude depression.

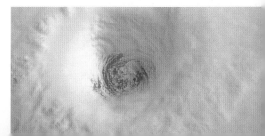

OBSERVING THE WEATHER

The best way to become familiar with weather patterns is to record the existing weather. The log need not be elaborate, but will be found to be extremely useful, especially if you also keep details of forecasts issued for the same period. Even without any measurements, enough information may be recorded to make it worthwhile. Some measurements, particularly of pressure, are very significant for activities, such as sailing, where the weather is all-important.

Details that should be noted, if possible:
- date and time
- cloud types and cloud cover
- pressure
- wind speed and direction
- temperature
- precipitation

Observations at meteorological stations are made on the hour, so it is sensible to make your own at the same time. Try to check the weather at 09.00, because that is the standard time at which climatological stations record their measurements. If you are sailing over some distance, it is sensible to record observations every three hours.

If you take photographs (pp.252–245), always make a note of the date and time.

It does take practice to recognise clouds and other features, so do not be disheartened if you are not able to identify everything immediately. Any particularly unusual phenomena should be noted in

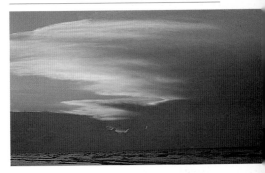

detail and photographs obtained if possible. Some phenomena, such as ball lightning and certain halo arcs, are so rare that good observations and photographs would be valuable scientifically.

Cloud cover is estimated in eighths (called oktas), or tenths in North America. It takes some practice to do this accurately, because you have to allow for perspective effects near the horizon. A rough estimate will suffice, unless you are actually submitting reports to a weather service.

There are many amateurs who record observations, and considerable numbers now have equipment for receiving images from meteorological satellites. They often progress from keeping records for their own interest to contributing data for climatological records. Some

even become officially certified weather stations, in which case both instruments and site have to meet certain criteria concerning accuracy and exposure, so that observations may be directly comparable with those from other sites around the world. Accurate, electronic versions of many instruments are now available at reasonable cost.

Pressure is the most important factor, so a barometer is the first instrument to obtain. Some older barometers are graduated in inches or millimetres, but most later versions show the pressure in millibars. Meteorologists now use hectopascals, hPA, in technical discussions. The conversions are:

- 1 in = 33.863 mb
- 1 mm = 1.3332 mb
- 1 mb = 1 hPA

Because pressure varies with altitude, all measurements are referred to sea level. Weather forecasters often suggest when it is a good idea to set barometers, normally when pressure is high and shows little change.

Barographs, which record continuously on a weekly chart, give a visual trace of variations, which is extremely valuable, because it enables you to see when fronts, and other, less well-defined troughs pass by. They are also essential for determining pressure tendency, which would otherwise require observations at very short intervals.

Pressure tendency is important and is measured

over a period of three hours. The terms used in forecasts and the amount of change are:

- steady less than 0.1 mb
- rising or falling slowly 0.1 – 1.5 mb
- rising or falling 1.6 – 3.5 mb
- rising or falling quickly 3.6 – 6.0 mb
- rising or falling very rapidly over 6.0 mb

Rapid changes indicate that a weather deterioration is imminent. This may take the form of sustained strong winds (around lows) or severe squalls associated with thunderstorms. Rising pressure does not always mean an improvement in weather. A surge of cold air causes a sharp rise, yet may bring heavy clouds, rain, snow, or storms.

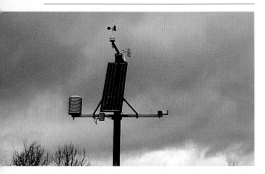

All temperatures used in weather forecasting are shade temperatures, so thermometers or electronic sensors are never exposed to sunlight. Meteorological stations either use louvred screens (known as Stevenson screens, see photograph on p.237), or marine enclosures, which look like an inverted stack of soup plates (above). The standard screen height is 1.25 m above the ground, and temperatures quoted apply to this height.

Standard observing stations record:

• maximum and minimum temperatures
• dry and wet bulb temperatures

The second pair of measurements is obtained by using identical thermometers. One bulb is kept moist by a sleeve with a wick to a container of distilled water. From the difference between the

wet and dry readings the relative humidity of the air may be calculated.

Wind speeds are measured by various forms of anemometer, and at official observing stations are mounted on masts at a standard height of 10 m. All reported speeds are for this height. Wind directions are given in tens of degrees, measured from north through east, although compass points (S, SW, etc.) are often used in forecasts.

Sunshine is not easily recorded. Until recently, the only satisfactory recorders used a glass sphere to burn a trace onto a daily card (above). Measurement of the trace was the greatest source of error. Accurate electronic devices have finally become available.

Accurate measurement of precipitation requires some care. The rain gauge must be sited so that it

239

is not affected by eddies, and does not catch splashes. (Snow is measured by special snow gauges that weigh the amount collected, or by melting it and treating it as rain.) Raindrops that are smaller than 0.5 mm are known as drizzle:

- light drizzle visibility more than 1 km
- medium drizzle visibility between 500 m
 and 1 km
- heavy drizzle visibility less than 500 m

Raindrops are above 0.5 mm in diameter:

- light rain 0.5 mm or less/hr, individual
 drops easily seen
- moderate rain 0.5–4 mm/hr, drops not
 easily seen
- heavy rain more than 4 mm/hr, rain falls
 in sheets

There are increasing numbers of fully automatic weather stations. They may be encountered almost anywhere, from small stations that monitor conditions at important points on a road network, to large, instrumented buoys (opposite), anchored in mid-ocean.

Such coverage is essential for accurate forecasting. Global weather systems are so interdependent that conditions over large areas must be taken into account. To forecast a given time ahead the approximate areas to be covered are:

- 1 day about 5,000 km across
- 3 days the entire hemisphere
- 5 days the whole world

Photographing the Sky

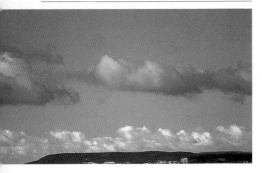

Photographing clouds and other atmospheric phenomena is not difficult, but some effects are so rare (or vanish so quickly) that you really need to carry a camera whenever possible. Although dramatic effects may be achieved with black-and-white film and yellow, orange or red filters, generally, colour films are best. Because of limitations of colour emulsions, however, some effects (such as purple light, p.109) are very difficult to capture. Standard prints from negatives often lose detail in the clouds, because printing machines compensate for dark foregrounds.

Some clouds and optical phenomena occupy a large part of the sky, so a wide-angle lens is helpful. (On 35mm film, a 24mm lens covers enough sky to include a secondary rainbow or 46° halo.) Other

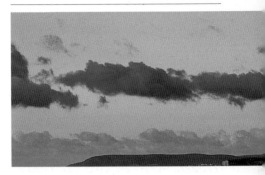

details may require a telephoto lens. So a single-lens reflex camera with interchangeable lenses is ideal.

A polarising filter is almost indispensable, because it can darken or lighten the sky background. It has greatest effect at about 90° from the Sun, and least effect directly away from (or towards) it. Always experiment with a filter, because it sometimes causes dramatic differences in the appearance of clouds. These photographs were taken one after the other, with different orientations of the polariser. Ensure that you obtain the correct type of filter for your camera. Some require a circular rather than linear polariser.

A good lens hood for each individual lens is essential. Delicate colours, such as iridescence (p.126) often appear close to the Sun, so lens flare

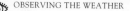

and stray reflections must be avoided, not least because they may sometimes mimic other atmospheric optical effects. Block out the Sun when photographing haloes or coronae.

Slight underexposure usually shows most detail in clouds and gives the most saturated colours with transparency films. Sophisticated cameras with spot metering are ideal, and are particularly valuable in dealing with brilliantly lit clouds or snow scenes.

Photography from aircraft is often rewarding, most particularly when the air is dry and clear. Atmospheric haze is a problem because it reduces

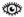

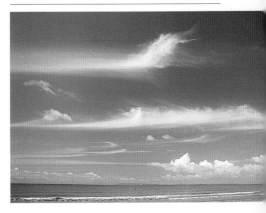

the contrast, resulting in disappointing pictures. Polarising filters cannot normally be used, because the plastic used in aircraft windows creates broad bands of brilliant colours.

If you attempt to take photographs under rainy or dusty conditions, protect the lens with a skylight filter (a sensible precaution at other times as well) and a lens hood. The camera itself may be enclosed either in a special (and expensive) water- and dust-proof housing or, more simply, by protecting everything except the lens aperture by a transparent plastic bag, through which you can still operate the controls.

WEATHER FORECASTS

Apart from the familiar television, radio and newspaper forecasts, a much wider range of specialized forecasts is now available. Many are designed for people with particular interests, such as skiers, mountain walkers and climbers, sailors and surfers. These forecasts are commonly available by telephone or fax, but others may be obtained through the Internet, or by subscribing to specialized computer services.

Aviation and shipping forecasts are broadcast from land and satellite stations. Radio shipping forecasts seem to be regarded as somewhat mysterious, and generate the most interest in the general public. In fact, they follow a fixed pattern and enable sailors to plot their own weather charts. To economise on time, certain words, such as 'wind', 'force', 'weather' and 'visibility' are omitted. Descriptive booklets and blank charts that show sea areas (opposite) and locations of coastal stations are widely available but, briefly, the forecasts consist of three parts:

- General synopsis
- Sea area forecasts (given in a fixed order)
- Coastal station reports (also in a fixed order)

The general synopsis describes the current situation, with the position of the dominant lows, high or troughs, and how they will move over the next 24 hours.

The sea area forecasts describe current and forecast conditions, in fixed sequence: wind (e.g. 'NW, 4, backing SW and increasing 5 to 6 later');

weather ('showers at first, rain later'); and visibility ('good, moderate to poor later').

The reports for coastal stations give: wind, significant weather, visibility (with actual distances for manned stations), pressure ('985'), and pressure tendency ('falling slowly').

WEATHER RECORDS

Driest place with official records, Quillagua, Chile, 0.5 mm average yearly rainfall

Lowest mean annual rainfall: 0.1 mm, Pacific coast of Chile

Most intense rainfall: 38.1 mm in one minute, Barst, Guadeloupe, 26 November 1970

Most rainfall in one day: 1,870 mm, La Réunion, Indian Ocean, 16 March 1952

Most rainfall in one year: 26,461 mm, Cherrapunji, India, 1 August 1860 to 31 July 1861

Greatest average annual rainfall: 11,873 mm, Mawsynram, Meghalaya State, India

Windiest place: sustained wind speeds of up to 320 km/h throughout year, Commonwealth Bay, George V Coast, Antarctica

Highest recorded wind speed: 371 km/h, Mt Washington, New Hampshire, USA, 20 March 1986

Highest tornado wind speed: 512 km h⁻¹, Oklahoma, 3 May 1999

Highest recorded jet-stream speed: 656 km/h, above South Uist, Outer Hebrides, Scotland, 13 December 1967

Lowest recorded temperature: –89.2°C, Vostok, Antarctica, 21 July 1983

Lowest temperature for a permanently inhabited place: –68°C, Oymyakon, Siberia, 1933 (unofficial subsequent record –72°C)

Lowest mean annual temperature: –58°C, Polus Nedostupnosti (Pole of Inaccessibility), Antarctica

Hottest mean annual temperature: 34°C, Dallol, Ethiopia

Highest recorded temperature: 58°C, Al'Aziziyah, Libya, 13 September 1922

Greatest temperature rise: 27°C (−20°C to 7°C) in two minutes, Spearfish, South Dakota, USA, 23 January 1943

Greatest temperature drop in one day: −56°C (from 7°C to −49°C), Browning, Montana, USA, 23–24 January 1916

Greatest temperature range recorded: 105°C (from −68°C to 37°C), Verkhoyansk, Siberia

Greatest annual sunshine total: 4,300 hrs (97% of total possible), Eastern Sahara

Lowest surface pressure: 870 mb within typhoon Tip, west of Guam in the Pacific Ocean, 12 October 1979

Highest surface pressure: 1083.8 mb, Agata, Siberia, 31 December 1968

Highest annual number of days with thunder: 322, Bogor, Java, Indonesia, between 1916 and 1919

Highest waterspout: 1,528 m, off Eden, New South Wales, Australia, 16 May 1898

Deepest clouds: 20 km, cumulonimbus in tropics

Longest measured lightning channels: 32-32 km

Largest single hailstone: 1 kg, Gopalganj, Bangladesh, 14 April 1986

Largest hailstone aggregates: 3.4 kg, Hyderabad, India, 1939 and 4 kg, Yüwu, China, 1902

Greatest daily snowfall: 1,930 mm, Silver Lake, Colorado, USA, 14–15 April 1921

Greatest single snowfall: 4,800 mm, Mt Shasta Ski Bowl, California, USA, 13–19 February 1959

Greatest depth of snow: 11,460 mm, Tamarac, California, USA, March 1911

Greatest snowfall in one year: 31,102 mm, Paradise, Mt Rainier, Washington, USA, 19 Feb 1971 to 18 Feb 1972

GLOSSARY

anticyclone A high-pressure area, in the centre of which air is subsiding, and from which air spreads out over the surrounding region. The circulation around an anticyclone is clockwise in the northern hemisphere (p.210).

antisolar point The point on the sky directly opposite the position of the Sun (p.119).

backing To change wind direction anticlockwise, i.e., in the northern hemisphere: from west, through south, to east.

cell A centre of organised convective or electrical activity within a cumuliform (particularly cumulonimbus) cloud, with strong up- or down-draughts.

condensation The process of the formation of water droplets from water vapour.

convection The transfer of heat by the motion of parcels of air. In the atmosphere this motion is predominantly vertical. There are two forms of convection: 'natural convection' in which parcels or 'bubbles' of air are free to move vertically through buoyancy effects, and 'forced convection' in which air is mixed mechanically by eddies.

convective clouds Those clouds (the cumulus family) in which there is a vertical circulation caused by temperature differences.

Coriolis effect The deflection of a moving object (such as a parcel of air) from a straight-line path. In the northern hemisphere the action is towards the right (clockwise), and in the southern, to the left (anticlockwise) (p.163).

cyclone This has two specific uses:

1 A 'tropical cyclone' is the technical term for a hurricane or a self-sustaining tropical storm, with both ascending and descending air currents.

2 An 'extratropical cyclone' or depression is a low-pressure area where air rises in the centre (p.196).

depression The common name for a low-pressure area, with rising air at its centre. The technical term is 'extratropical cyclone'. The wind circulation around a depression is anticlockwise (cyclonic) in the northern hemisphere (p.196).

dewpoint The temperature at which condensation occurs.

evaporation The process in which liquid water turns into (invisible) water vapour.

front The boundary between two air masses of different temperatures and humidities.

generating heads Small, individual cloudlets that are producing precipitation that give rise to cirrus (p.40) or virga (p.84).

instability The condition under which a parcel of air, if displaced upwards or downwards, tends to continue (or even accelerate) its motion (p.98). The opposite is stability.

inversion A layer in which temperature increases with height (p.96).

isobar A line on a weather chart that joins points at the same barometric pressure (p.184).

jet stream A narrow band of high-speed wind that flows just below the tropopause (p.165)

lapse rate The rate at which temperature decreases with height (p.96).

latent heat The heat that is released when water vapour condenses or ice crystals form. It is the heat that was originally required for the process of evaporation or melting.

polar front The front separating polar and tropical air masses (p.176), at which most mid-latitude depressions form.

precipitation The technical term for any liquid or solid water that is deposited from the atmosphere, but which does not necessarily reach the ground (p.142).

shear A marked change in the speed or direction of the wind that occurs in an extremely shallow layer.

stratosphere The second major atmospheric layer from the ground, in which temperature increases with height. It lies between the troposphere and the mesosphere (p.96).

stability The condition under which a parcel of air, if displaced upwards or downwards, tends to return to its original position rather than continuing its motion (p.98).

supercooling Conditions under which water exists in a liquid state, despite being at a temperature below 0°C (p.144).

synoptic chart A chart showing the actual (measured) conditions prevailing at different observing sites at a particular time.

thermal A parcel of air, with an internal circulation, that is rising because its temperature is higher than that of its surroundings (p.95).

tropopause The inversion that separates the troposphere from the overlying stratosphere (p.96).

troposphere The lowest region of the atmosphere in which most of the weather and clouds occur (p.96).

veering To change wind direction clockwise, i.e., in the northern hemisphere: from east, through south, to west (p.163).

INDEX